Dictionary of
Printmaking Terms

Printmaking Handbooks

Series advisor: Rosemary Simmons

Dictionary of Printmaking Terms

ROSEMARY SIMMONS HON. RE

DRAWINGS BY JANE STOBART RE

A & C BLACK • LONDON

DEDICATION

To all artists who willingly share their skills and knowledge.

First published in Great Britain 2002

A & C Black (Publishers) Ltd

37 Soho Square, London W1D 3QZ

www.acblack.com

Copyright © 2002 Rosemary Simmons

Drawings © 2002 Jane Stobart

ISBN: 0 7136 5795 2

Front cover illustrations: drawings by Jane Stoba Top row, middle illustration: *Dharma light*, fused silk, reactive dyes, painted and printed, by Jason Pollen. Middle row, left: Reactive dyed, screen-printed pigment and discharge on silk satin by Fiona Claydon. Middle row, right: *Attractor*, woodblock print on Japanese paper by April Vollmer. Bottom row, middle: *Girl with a cat* (detail) by Clarke Hulton, courtesy of the University of Wales, Aberystwyth.

Opposite: Columbian Press (see page 31 for deta

Cover design by Dorothy Moir.

Design by Keith & Clair Watson.

Printed and bound in Great Britain by The Cromwell Press Ltd, Trowbridge, Wiltshire.

A&C Black uses paper produced with elemental chlori free pulp, harvested from managed sustainable sources

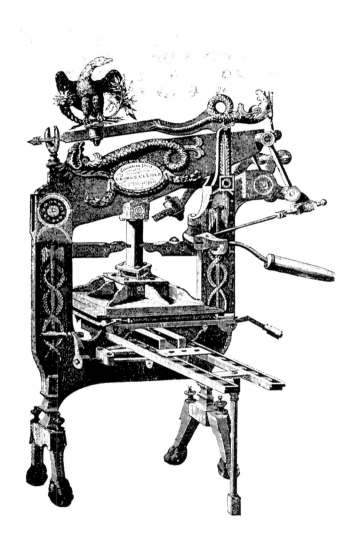

INTRODUCTION

■ The idea for a *Dictionary of Printmaking Terms* came from Linda Lambert, the original editor of this new series of books on printmaking. Luckily, it was something I had wanted to compile for a long time for, back in 1965 when I started a print gallery, I realised that the terminology we used was a barrier with the public and with artists who worked in different media. Later, when I was teaching, I understood that obscure words held the knowledge of past artists and their discoveries.

The choice of terms to include is to some extent personal (they are things that I had wanted to understand myself at various times), but I have tried to put myself in the place of a student or artist who, perhaps, knows about etching but wants to go into screenprinting and needs to check out some new words. Or a gallery curator who is confused between monotype and monoprint. Or a collector who wants to understand the differences between techniques which shelter under umbrellas such as 'intaglio' or 'digital'.

I hope that, while browsing through this dictionary, readers will come across an unknown term which will intrigue them enough to seek out more detailed information and perhaps discover a new way of working.

I have not attempted to include every foreign language equivalent but only those an English speaking reader is likely to encounter. So, for example, I have not included every subtle Japanese woodblock technique or the names of all the Japanese brushes or papers but only those a reader may find in a catalogue of materials and equipment. Likewise, I have given the chemical formulae for most substances printmakers use with the exception of certain mixtures which can vary according to manufacturer such as some of the hydrocarbon based solvents or some complex chemicals on which science dictionaries disagree.

I have drawn on the books so far published by A & C Black in this new printmaking series and thank the authors for bringing the terminology up to date. I have also drawn on a wide number of historical texts and standard works, but printmaking is always changing with new materials and new ingeneous ways of working so new terms will continue to be invented and redundant terms may be revived as old ways are reassessed. I would like to thank Jane Stobart for her illustrations, Martin Easteel for help on book-binding terms and Steve Hoskins who read the manuscript and pointed out omissions and made improving suggestions.

I hope this collection of terms is both helpful and stimulating.

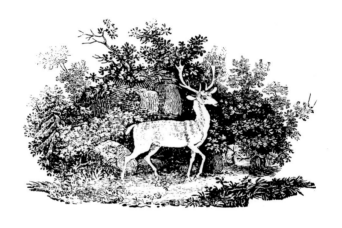

Stag, wood engraving by Thomas Bewick, c. 1790.
(See page 127 for details on wood engraving.)

A

Abrasives: Solid or powder form polishing agents such as snake stones, Rotton stone, carborundum (silicon carbide), pumice, jeweller's rouge and engraver's charcoal.

Accordion binding: *See* concertina binding.

Acetate film: Used to set up accurate positioning for visual registration of printing blocks; used for masking areas on printing paper; used for transferring images from one surface to another.

Acetic acid (CH_3COOH): De-greasing agent used in stone lithography.

Acetone (CH_2COCH_3): Dimethyl ketone. A colourless, flammable liquid used to de-grease surfaces.

Acetyl homopolymer blocks: A synthetic resin wood engraving material sold as Delrin and Tecaform AD.

Acid: A corrosive liquid used to etch metal plates or lithographic stones and plates. Also known as a mordant.

Acid-free: pH is expressed on a scale of 0-14, from acidity to alkalinity; pH7.0 is neutral. Used with particular reference to paper. Acid-free papers and boards are recommended for fine printmaking and framing.

Acid tint: A method of drawing on lithographic stone using nitric acid to burn the image into a darkened (inked) area. This creates a tonal image in greys. It was developed in 1964 by Ken Tyler at Tamarind Workshop in Los Angeles, USA.

Acid trays: Shallow trays for containing acid during etching, made from a non-corrodable material.

Acquaforte, all'acquaforte: Italian for an etching.

Acquafortis: Latin for nitric acid (literally strong water).

Acrograph: See gypsograph.

Acrylic hard ground: A copolymer intaglio ground developed to replace traditional hard ground.

Acrylic modelling paste: Used to build a printing surface on relief and intaglio plates, particularly used in collagraph.

Acrylic resist intaglio: An alternative system for making etchings using acrylic-based materials to replace traditional grounds and solvents.

Acrylic reversal: A technique used in stone lithography first described by John Sommers in 1974 at the Tamarind Workshop, USA.

Actinic light: Chemically active light used to harden photo-sensitive coatings and films obtained from mercury vapour lamps, metal halide, photo-flood bulbs and carbon arc lamps (the last are no longer used for health and safety reasons).

Additives: Substances added to inks to delay drying, advance drying, bulk up or dilute pigments.

Adhering liquid: A US term for a cleaning fluid, such as lacquer thinners, which is used on screen mesh just before adhering a stencil.

Aerograph: The trade name for an airbrush made by DeVilbiss. Airbrushes are used in printmaking to produce a fine spray of acid-resist solution or opaque black ink on paper or film using compressed air.

Aerosol enamel paint spray: Can be used to spray an acid resist on an etching plate. Cellulose-based enamels should be avoided as both enamel and solvents used are highly toxic. Acrylic-based enamels, dissolved in turpentine substitute, are preferable.

Affiche originale: Used in France to denote a poster created by an artist, usually for the artist's own exhibition, often signed and numbered, usually lithographs or screenprints.

Airbrush printing: Electronically controlled atomised printing on a very large scale used for posters, signage and backdrops on a variety of substrates.

Aisuki: Japanese flat bladed chisel.

AISUKI

A la poupée: French for a method of inking a printing plate with several different colours using small dabbers, rolls of felt or a 'dolly' of twisted cloth or scrim.

Albertype: An early name for collotype.

Albion Press: Cast iron platen press invented in 1822 by R. W. Cope in Britain. Simpler than the Columbian but equally highly prized by printmakers.

Album: A Japanese style of binding in which single pages are folded in half inwards and pasted into a concertina book.

Albumen: A natural protein found in egg white used in some bichromated photo-sensitisers. Also used in bookbinding as size in gold stamping and the application of gold to the edge of book pages.

Albumen print: A photographic print using albumen.

Alcohol: Used as a solvent.

Algraph: Aluminium plate lithograph.

Aliphatics: A group of hydrocarbons including white spirit (mineral spirits) and naptha which are surface irritants but less harmful than aromatic hydrocarbons.

Alkali mordants: Used to etch linoleum. Caustic soda (sodium hydroxide, $NaOH$), paint stripper and strong alkaline screenprint cleaning pastes are the most commonly used. The block is left with a speckled texture where bitten.

Alkyd varnish: A constituent of some printing inks, derived from hydrocarbons.

All-digital prints: Images made by a computer-controlled output device without using any traditional non-digital methods.

Alpha channels: Extra computer channels used for making masks.

Alum ($Al_2(SO_4)_3K_2SO_4 \cdot 24H_2O$): Aluminium potassium sulphate. The solution is used to strengthen and waterproof very fine papers. It is used in weak lithographic etches. The group of alums includes chrome alum ($KCr(SO_4)_2 \cdot 12H_2O$) and potassium chrome alum ($K_2SO_4 \cdot Cr_2(SO_4)_3 \cdot 24H_2O$) which is used in etches for zinc lithographic plates. Alum is also used as a mordant in marbling.

Alumina hydrate ($Al(OH)_3$): A white inorganic pigment used to extend printing inks.

Aluminium foil: Used to create a crinkled surface on relief or collagraph blocks. Used to wrap up small amounts of printing ink.

Aluminium ink: An ink which uses aluminium powder as the pigment.

Aluminium oxide (Al_2O_3): Alumina. In grit form it is used as an abrasive in preparing lithographic stones.

Aluminium plates: Grained metal sheets used for lithography were introduced in 1891, today the plates are usually alloys. It takes a sharper grain than zinc and is more porous but retains crispness during editioning. Aluminium is used for etching plates and is bitten in cupric chloride ($CuCl_2$) or caustic soda; the result can be rather coarse in comparison to copper and wears quickly.

Amberlith/Rubylith: Stencil masking films which are cut with a knife. They are made from a light opaque plastic on a polyester backing film.

Ammonia (NH_3): A colourless gas which is soluble in water (household ammonia) and used to de-grease a printing surface; it is also added to some light-sensitive solutions.

Ammonium bichromate ($(NH_4)_2Cr_2O_7$): Used to make a light-sensitive solution for lithographic stone. *See also* potassium bichromate.

Ammonium fluoride (NH_4F): Used in etches for zinc lithographic plates.

Ammonium nitrate ($NH_4 \cdot NO_3$): *See* ammonium fluoride.

Ammonium phosphate ($(NH_4)_2HPO_4$): *See* ammonium fluoride.

Ampersand: A typographic term for the shortened version of 'and' (&), derived from the French 'et'.

Anaglyptograph: A device introduced in the 1820s with a needle which followed the contours of a medal or other shallow relief turning them into engraved lines. *See also* ruling machine.

Analine printing: Similar to the blueprint, also an alternative name for flexography until analine dyes were banned from food packaging in 1952. *See also* flexography.

Anastatic printing: A form of transfer lithography developed in the 1840s; also used to reproduce fresh or recent drawings as etchings. Anastatic Printing Societies were popular with amateur artists.

Anglet or angle graver: A US term for an engraving tool with one side ground to an angle.

ANGLET

Anode: The positive pole in electroplating and etching.

ANSI: American National Standardization Institute has determined colour graphic applications. *See also* CIE.

Anti-aliasing: A digital method of smoothing jaggedness of lines and edges in pixel-mapped images.

Anti-drying agents: Additives to printing ink which retard drying. Glycerine is added to water-based inks and either Vaseline, poppy oil or turpentine substitute is added to oil-based inks. Aerosol anti-oxidation sprays are made for the printing industry which retard the formation of ink skin on rollers, ink slabs and ink in tins.

Anti-halation meshes: Screen meshes dyed orange prevent the reflection and scattering of light when making direct coated stencils, which is important in fine detail.

Anti-tinting: A solution of gum arabic, water and phosphoric acid used in lithography to prevent and cure scumming (tinting). Anti-tinting medium is added to water based lithography inks.

Antiquarian: Paper size: approximately 790 x 1350mm (31 x 53in). First made by Whatman in 1774.

Aquachrome: A hybrid photographic technique. Paper is coated with a gelatine bichromate solution containing some watercolour. After exposure the unhardened gelatine is washed off and the remaining image, being still soft, can be manipulated by hand. Further coats with different colours can build up subtle images.

Aquapel: Used in paper manufacture to replace size.

Aquatint: Intaglio prints where solid ink areas are broken into small ink pits of variable size creating a wide range of tones. Traditionally obtained by dusting the plate with a fine resin powder which acts as a resist to acid. Resin dust is evenly

deposited in a dust box or can be randomly deposited from a sifter or dust bag. Alternatives are opaque black ink droplets deposited by an airbrush, a mouth diffuser or by flicking a brush. *See also* dust box.

Aquatint box: *See* dust box.

Aquatinta-Verfarhren: German for aquatint.

Arabic figures: Numerals derived from Arabic i.e.1,2,3 etc. *See also* roman numerals.

Archival inks: Coloured printing inks which are expected to last without fading for 10-50 years; black ink for 100 years.

Archival paper and boards: Acid-free paper and mounting boards designed for long-term stability. Also called museum boards.

Archiving: A computer term for the storage of digital data.

Arkansas stone: A fine abrasive stone used to sharpen cutting tools.

Aromatics: A group of hydrocarbons including benzene, toluene and xylene which are absorbed through the skin and nose and are considered very toxic.

Art paper and board: Paper and board which has a matt or glossy coat of china clay which makes it very receptive to printing ink.

Artist's books: A book totally designed by the artist and produced in small editions using printmakers' techniques. Often a collection of prints with supporting text issued on subscription; often a collaboration with other artists and/or with technicians and bookbinders. A strong European tradition but now developed by printmakers everywhere.

Artist's proofs: Copies of a print identical to the edition but for the exclusive use of the artist for archives, sale or gifts. Normally not more than 10% over the edition size. Signed by the artist on the left hand side 'artist's proof', or 'ap'.

Artists' original prints: *See* original print and BSI.

Artotype: Another name for collotype.

Artwork: The original drawings, paintings, photographs or text proofs used in photomechanical reproduction.

Ascenders: A typographic term for the parts of a letter above the x-height i.e. b,d,h etc. *See also* x-height and descenders.

Asphaltum: A naturally occurring bituminous mixture of hydrocarbons used in inks, varnishes and as an acid resist.
Asphaltum powder in an organic solvent (washout solution) is used in lithography to make a printing image ink receptive.

Assemblegraph: A print taken from an assembly of printing blocks, not cut from one piece like a jigsaw print.

Atomiser: Hand-held water spray used to dampen paper.

Auto-: A prefix to a print medium indicating that the artist created the matrix; originally used to differentiate an artist's work from commercial reproduction without the use of photography i.e. autolithography.

Autochrome: The early name for four-colour letterpress halftone; also used for early colour photography.

Autogravure: *See* sand grain photogravure.

Autotype: German and Dutch name for halftone photo-engraving. Also the English name for carbon printing or collotype and the trade name of the manufacturers of carbon tissue, who patented the carbon transfer process.

Authorized edition: *See* estate print.

Avant les lettres: On old prints, the state before the title, artist, engraver and publisher were engraved beneath the image; the state before editioning.

Awl: A sharp pointed tool used to make holes in boards during the binding of books.

AWL

Azo: A group of chemical pigments and dyes used in printing inks. Azo-type light-sensitive solutions are used on lithographic plates and Diazo groups are used in most reprographic emulsions.

DICTIONARY OF PRINTMAKING TERMS

B

Back: The margin of a book page nearest the binding. The back cover of a book.

Backing hammer: A bookbinder's tool used to round the back and similar processes.

Backing sheets: Various types of paper, plastic and rubber are used in the press between the printing paper and the pressure source giving a range of impressions from hard and sharp to soft and fuzzy or deeply impressed.

Ball rack: A system for hanging paper up to dry consisting of a series of balls and sockets suspended upside-down.

Banding: A computer term for a blend which has too few colours to make it smooth.

Baren: A Japanese burnishing tool, circular with a handle, covered in a bamboo sheath. They are made in many qualities and modern plastic equivalents are available.

Barium sulphate (BaSO$_4$): Barytes. *See also blanc fixe.*

Baseboard: The bottom board of a screenprinting press or table which should have a vacuum pump attached to hold the paper flat during printing. Most commonly called the vacuum table or floating bed.

Bat printing: A form of printing used to transfer an image from a printing plate to a gelatine or silicone surface and then to a ceramic surface.

Baumé: The measurement of specific gravity of liquids particularly used to check the

BAREN

strength of ferric chloride solution using a Baumé hydrometer.

Baxter print or Baxtertype: George Baxter patented in 1835 a system with a monochrome aquatint key plate and up to 20 woodblocks printed in colour.

Bearing grease: Press lubricant.

Bear's breath: A mixture of half turpentine substitute and half methylated spirits plus 10% hydrochloric acid is used to clean copper intaglio plates.

Beating: The macerating of paper pulp.

Bed: The solid, flat base of all flat-bed printing presses, on which the printing plate or block is placed or the printing paper when a block is positioned on top; also the base of a screenprinting press.

Beeswax: Used as an acid resist and as a constituent of lithographic crayons. Also known as virgin wax.

Before letters: *See avant les lettres.*

Bench stop or hook: A woodworker's device for holding a woodblock steady while cutting.

Ben Day tints/medium: Sheets of transparent film embossed with

BENCH STOP OR HOOK

mechanical patterns of dots, lines, textures etc. were inked and transferred to add areas of tone to a drawing before photography or to the plate before etching (process engraving) or to lithographic stone or plate. Common in commercial printing during the 1920-1950s on newspaper cartoons and diagrams.

Benzine: Aromatic hydrocarbon derived from petroleum (not to be confused with benzene). Used as a grease solvent.

Bevel: The angled edge of a metal or plastic plate which avoids cutting the printing paper or blankets; the angled edge of a window mount, which is often used decoratively by colouring or gilding.

Birch-faced plywood: Used for relief blocks; particularly favoured by Asian artists using water-based printing as it is a cheap substitute for traditional blocks made of cherry and other hardwoods.

Biscuit firing: The first firing of clay before glazing.

Bit: A binary digit or smallest unit of digital data.

Bits per pixel: The number of bits needed to represent the colour of a single pixel.

Bite: The corrosive action of acid on a metal plate in all forms of etching; the action of an alkali etch on lino.

Bitumen of Judea: A soft asphaltum used in some lithographic crayons. It was used by J.-N. Niepce to make the first permanent photographic images.

Blanc fixe: Semi-opaque white pigment used as a cheap ink extender.

Blanket: The pieces of felt placed between an intaglio press top roller and the printing paper forcing the paper into the inked intaglio areas; a rubber covered roller on an offset lithographic press which takes up the inked impression from the plate or stone and transfers it to the printing paper.

Bleach: Chlorine once used to whiten paper pulp.

Bled image: When the image extends to the edges of the paper or when the paper is trimmed into the printed area: there are no margins. Also called a bleed print.

Bleeding colour: Colour pigment which spreads beyond the printed area to leave a 'halo' effect on the paper. Can be artificially contrived by spraying the back of the paper with a solvent.

Blended colours: Where more then one coloured ink is rolled on the ink slab and gradually blended together by the roller or when put on a screen, by the squeegee. Also known as merged colours, rainbow colours or, in machine lithography, split duct.

Blind embossing: Where an uninked block or plate is forced into dampened paper leaving a three-dimensional image using an intaglio press or by hand using a rounded point.

Blind stamp: *See* chop mark.

Blind tooling: A method of decorating a leather binding with a heated finishing tool which leaves a darker impression. *See also* finishing tool.

Block: A printing surface made of a thickish material such as wood, lino, vinyl; thicker than a plate.

Block book: An early book in which each complete page or pair of pages is carved from a single piece of wood, type and illustrations together.

Blocking press: A heavy metal press with a heating element for the brass type (or blocking brass) used with gold leaf or metallic foils to title books.

Block-out: A liquid painted on the surface of a block, plate, screen or artwork which acts as a resist to acid, alkali, ink or a light source. Larger areas can be covered by suitable plastic sheet or film.

Blotters: Absorbant unsized blotting paper used between sheets of dampened paper to maintain moisture or when drying paper. It is also used as backing sheets in the press.

Blue Wool Scale: *See* colour fastness.

Blueprint: Paper impregnated with a light-sensitive solution used to make negative copies of plans or drawings. It has been used by artists but it soon discolours and has now been replaced by photocopying.

Board: Any paper that is heavier than 90lb per ream or 220gsm. Also the stiff part of a binding for a book, back and front and attached to the spine, which protects the leaves. *See also* paper weights.

Body: Describes the consistency of printing ink; also the mass of a metal typeface measured from front to back of the metal shank which supports the character of type.

Bokashi: Japanese technique for making a blended colour on a woodblock.

Bold: A typographic term for a thick and heavy type design. Many faces have bold versions.

Bon à tirer: French for good to print, this instructs the printer to print the edition using this proof as the guide. Written in pencil on a proof. Also written as BAT. These proofs sometimes come on the market and are of special interest.

Bond paper: A lightweight sized paper used for writing.

Bone: A flat, thin length of bone, wood, plastic or metal used when folding paper to smooth a crease.

Bookplate: A label denoting ownership of a book pasted inside a book cover. Usually artist-designed in wood engraving, woodcut or lino print.

BONE

Borax ($Na_2B_4O_7 \cdot 10H_2O$): Disodium tetraborate is used as a water softener in paper pulp.

Bordeaux etch ($CuSO_4 \cdot 5H_2O$): Saturated copper sulphate solution used as a mordant for etching zinc.

Boxwood: Hard wood used for wood engraving on the end grain. Was also used for display type (large sizes) in letterpress.

Brass: Sheets of brass can be used for intaglio using the same acids as for copper.

Brayer: US term for an ink roller.

BRAYER

Bristol board: Sized and compressed papers from one to five ply thickness are given a polished surface which makes them useful for pen drawing, artwork and calligraphy.

Broadsheet: A sheet of unfolded paper printed on one side only.

Bromoil: An early 19th century photographic process. A silver image is bleached out by chemicals and is replaced with oil-based inks or paint. The image can also be transferred to another paper.

Brush inking: Printing ink applied to the block or plate by brush. The brush marks usually show on a non-absorbent surface i.e. oil-based ink on a metal plate. They are not usually evident using water-based colours on an absorbent material such as wood as in traditional Japanese woodblock printing.

BSI: British Standards Institute published BS 7876:1996 to establish a system of catagories for all print production and distinguishes prints according to the extent to which the artist named as inventor was actually involved in the print. It covers all prints from hand-printed artists' prints to commercial reproductions. It requires a minimum paper weight of 250gsm and a Blue Wool Scale minimum of six for ink quality. *See also* original print.

Bubblejet printer: A type of drop-on-demand inkjet printer.

Buckling: US term for paper which has developed a wavy surface. *See* cockling.

Buffered papers: An alkaline additive of calcium or magnesium carbonate to paper pulp ensures a neutral pH in the finished sheet.

Bullsticker: A steel tool for wood engraving similar to but broader than the spitsticker, with swelling sides, used for bold marks and clearing areas.

BULLSTICK

Burin: A group of steel engraving tools, also called gravers, with pointed, elliptical or lozenge-shaped tips. The word is interchangeable with 'engraving' to describe the typical line which results from engraving.

Burnisher: *Brunisseur* (French) *Polierstahl* (German). A polished steel, slightly curved tool used to smooth a metal plate surface for corrections or to lighten a tonal area in aquatint or mezzotint. A tool is used to apply pressure to the back of paper laid on an inked relief block which can be the back of a spoon, a rounded pebble, a piece of wood or a specially made tool. Bookbinder's burnishers are usually made from agate or other stone. *See also* baren, rubbing, dab printing and frottage.

BURNISHER

Burr: The roughened edge of metal on each side of a scratched or drypoint line, also the texture produced by a mezzotint rocker. The burr holds ink and is characteristic of a drypoint. The burr wears away rapidly during printing and if many copies of the print are needed the plate should be steel-faced.

Butterfly binding: A Japanese style of binding in which double page spreads are folded inwards, stacked up and each pasted along the innerfold to the next adjacent fold.

Byte: A computer term for a group of eight bits. *See also* bit.

C

CAD/CAM: Computer-aided design/computer-aided manufacture.

Cael., caelvit: Latin for 'engraved', seen on old prints.

Calcographia: Spanish and Italian for engraving (a portmanteau word used to include all forms of printmaking). Also a museum or collection of prints.

Calendered paper: Paper which has been rolled either at the mill to impart a smooth finish or in the studio prior to printing to stop the paper stretching. This helps in a coloured print which will go through the press many times and register is critical.

Calotype: An early photograph using a paper negative developed by Fox Talbot.

Cancellation: A printing block, stone, plate or screen is cancelled when the edition has been completed to ensure that another edition can not be printed. The printing matrix is defaced in some way: by engraving a cross over the work, by drilling a hole through a plate or by the use of acid. A cancellation proof is then pulled to show that no more can be printed.

Capitals, caps: A typographic term for the large letters in a font, also called upper case (uc) from their storage position in a compositors rack or case. *See also* lower case.

Caption: A typographic term for the title line (or other information) under an illustration in printed matter. Also called a legend.

Carageen moss: A vegetable mucilaginous gum used in the coating for lithographic transfer paper and for marbling.

Carbolic acid: *See* phenol.

Carbon paper: Used to transfer a design from one surface to another.

Carbon print: Introduced by

Alphonse Poitevin in 1855 and perfected by Sir Joseph Swan in 1864 using carbon tissue which is a bichromated gelatine film impregnated with carbon particles on a thin paper carrier. When exposed to a negative, light hardens the gelatine variably with a reticulated surface; this can be transferred to a flat surface such as copper, glass or paper. When rolled with ink, it is accepted variably, depending on the degree of water absorbed by the gelatine. Carbon prints on paper were called autotypes.

Carbon tetrachloride (CCl_4): A non-inflammable solvent used as a strong de-greasing agent. Should be avoided as it is toxic.

Carbon tissue: A paper used in the photogravure process. It is also called pigment paper. *See* carbon print. Currently only made commercially by the Autotype company in UK.

Carbon transfer print: A term used to describe the three-colour process which uses three- colour pigmented tissue.

Carborundum: Silicon carbide (SiC). An extremely hard abrasive widely used in printmaking. Carborundum paper in various grit grades is used to smooth blocks and plates; as a grit, again in various sizes, it is used with a glue on a printing matrix to provide a tooth for printing ink. A carborundum print is an intaglio print characterised by the unusually heavy ink load which can be held by the grit on the plate. *See also* collagraph.

Carboy: A large glass bottle used to store corrosive liquids.

Card: A lightweight machine-made board not often used as a substrate in fine printmaking but it is used as a matrix for card prints (card cuts, cardboard prints) in relief printmaking. Also used to move ink about during inking an intaglio plate, as make ready on the press, mounts for small prints and small pieces make stops on the press bed.

Cardboard: A general term for boards 15mm ($1/_{16}$ in.) or thicker.

Carnauba wax: Used in some lithographic crayons.

Carrier: Paper or some other substrate on which an image is made.

Cartridge paper: A tough machine-made paper, uncoated but surface sized, made from 90-220gsm and used for preliminary designs and proofing.

CAS: Computer-aided signmaking on a large scale. *See also* airbrush printing.

Case: A typographic term for a shallow wooden or metal tray which stores loose type, hence upper and lower case, one ranged above the other. Also the made-up book cover prior to fixing it to the pages.

Casein: Water-soluble colloid derived from milk used in light-sensitive solutions. Also used instead of glue in gesso which, if coated on to a board base and engraved, sealed and printed produces a casein engraving.

Cast off: The estimation of the length of a manuscript if set in a given typeface and size.

Cast paper print: The term is used for a blind embossed print but more commonly means a print for which paper has been specially made or cast, often of irregular shape and incorporating coloured pulp and deep textures.

Catalogue raisonné: A comprehensive scholarly catalogue of an artist's works.

Catalpa wood: A hardwood traditionally used by Chinese and Japanese woodblock artists.

Cathode: The negative pole in electroplating and etching.

Caustic potash (KOH): Potassium hydroxide. Household lye, used in solution as a de-greasing agent, in the developing of some photopolymer films and to remove work from zinc lithographic plates.

Caustic soda (NaOH): Sodium hydroxide: This stronge alkali is used in saturated solution to etch linoleum. Also called lye.

Ca zi: A Chinese burnishing tool made from a long rectangular block which fits the hand. A sheet of palm fibre is wrapped over a thin strip of wood which is then bound to the block of wood. It is used like a baren.

CA ZI

CCD technology: Charged coupled devices are used in digital cameras to record the image on a memory card.

CD-ROM: A compact disk used to install software into the computer or

to imput images or text and to store files. CDs have a 650MB capacity.

CD writer: Digital device which stores computer files in a permanent archive on CDs.

Cellocut: A print taken from a plate where the image has been made by dissolving celluloid in acetone and painting it on a plate; printed intaglio or relief.

Celluloid print: A print taken from an image scratched into celluloid sheet in the manner of drypoint. Now superseded by acrylic or other plastic sheet; printed intaglio.

Cellulose: The main component of paper derived from the cell walls of plants and trees.

Cellulose gum: Carboxymethyl cellulose, a synthetically-produced gum, is used as an alternative to gum arabic.

Cerograph: A 19th century process where a drawing was made through a wax ground and then electrotyped and printed letterpress.

Chalcograph: A term for any engraving on copper.

Chalk ($CaCO_3$) (Calcium carbonate): An alkaline white lump or powder used in intaglio printing to wipe the hand during the final cleaning of the plate prior to printing. White and coloured chalks in stick form are used for drawing and are closely related to pastels. Also the generic name for the lithographic drawing medium, also called crayon. Supplied in stick and pencil form, graded from soft to hard: No.00 is very soft to No.5 which is hard, copal is extra hard in UK and US systems. French manufactured lithographic chalk uses the opposite numbering. Hard contains less grease than soft. Bars and discs are used for rubbing areas on the stone or plate.

Chamois: A piece of fine leather used on the finger to rub lithographic crayon.

Character: A typographic term synonymous with letter.

Charcoal: In stick form it is used for guide drawings on paper or lithographic stone or plate as it is grease free, also used as the final polish on a very smooth lithographic stone or metal plate.

Charcoal paper: Used as a lithographic transfer paper.

Charging: The first application of printing ink to the matrix and the subsequent re-inking after each impression. *See also* flooding.

Chase: A metal frame into which formes holding metal type are locked ready for printing.

Cheese cloth: A fine, soft open weave cotton used to filter liquids and to apply them to lithographic stones and plates and in the retroussage of intaglio plates. *See also* retroussage.

Chemical engraving: A 19th century name for a lineblock or process engraving.

Chemical printing: Senefelder's name for lithography.

Chemitype: *See* chemical engraving.

Cherry gum: A natural hydrophilic gum which can be used as an alternative to gum arabic.

Cherry wood: A hardwood traditionally used for woodblocks by Chinese and Japanese woodblock artists.

Chiaroscuro woodcut: Early form of colour printing from wood using three or more separate blocks for tones of the main key block colour adding form to the composition.

China clay: Used in paper making to impart a smooth white surface; used with cotton linters (paper pulp) in paper clay which can be printed when leatherhard.

China paper: A thin paper made in China, also called India paper because it was imported by the East India Company. It is now machine-made and used for Bibles and reference books.

Chinagraph pencil: A very greasy crayon used for drawing in lithography; as an acid-resist drawing tool and for drawing on drafting film.

Chine collé: French term for thin paper, usually of Asian origin, which is glued, or collaged, on to a heavier backing sheet of paper. Often used only in the image area or in small separate areas on the print. Can be pre-printed and self-coloured or a colour different from the backing paper. Adhesives used include size, gum, rice paste, potato starch or dextrine with water; wheat starch paste is most commonly used today.

Chine volant: French for a very fine tissue-like Asian paper.

Chinese style binding: Somewhat similar to the Japanese four-hole binding but with slightly different stitching.

Chop mark: A blind embossed stamp in the corner of a print

denoting the artist, printer or publisher.

Chromiste: French for a craftsman who interprets a design by another hand creating intaglio, lithographic, relief or screenprinting matrices; also called the chromo.

Chromocollograph: Colour collotype.

Chromolithography: Colour lithography in which the image is drawn on separate plates or stones by a skilled artisan or chromo-lithographer. The term was coined by G.Engelmann in the early 19th century to denote colour crayon lithography. *See also* lithotint.

Chromotype, chromotypograph: A general 19th century term for any colour relief print from metal blocks.

Chromotypogravure: Tinted relief halftone print.

Chromoxylograph: Colour woodcut or wood engraving.

Chuban: Japanese paper size, approximately 394 x 265mm. ($15\frac{1}{2}$ x $10\frac{1}{2}$ in.)

Cibachrome: Trade name for a colour photographic system. Occasionally used by artists working in the hybrid field between printmaking and photography.

CIE (*Commission Internationale de l'Eclairage*): attempted to define colour systems in 1931 by developing the XYZ or norm colour system. In 1976 they developed the LAB colour space system so that every colour, in no matter what type of digital machine (monitor, colour printer, scanner, CD, colour copier or printing press) could be measured on two axes (a and b) plus L (brightness): the values should be constant.

CIJ: Continuous inkjet printers are slow but high quality and can print on many good printmaking papers.

Citric acid ($C_3H_4(OH)(CO_2H)_3 \cdot H_2O$): Used to re-sensitise or counter-etch lithographic stone or aluminium plates. Added to ferric chloride to make Edinburgh Etch.

Citrus solvent: Alternative cleaning products based on citrus oils.

Clay print: A design cut into an air- or heat-hardening clay slab which is then printed relief with low pressure or burnishing.

Cliché: European term for a letterpress halftone process block.

Cliché verre: French for glass print. An image is made on the darkened

surface of a glass sheet using an etching needle; a photographic print is made from this hand-drawn negative.

Clipped: A print that has been trimmed close to the image area leaving no margins. The plate mark in early intaglio prints was often trimmed off.

Closing: Used in lithography when printing is finished and the stone or plate is cleaned and prepared for safe storage.

CMC (Sodium carboxymethyl cellulose): A glue.

CMS: Colour management systems. *See also* CIE.

CMYK: The four process colours, cyan, magenta, yellow and black (key line), used in halftone colour printing. Also called the subtractive colours. These colours are not internationally standardised though Japan works to the JIS standard, the US to the Swop and in Europe there is the European Ink Set standard.

CNC cutting: Computer numerically controlled cutting devices used to make large-scale masks or images for outdoor signs. Also used to cut metals and other materials for printing blocks.

Coated papers: Papers with a coat of china clay may be glossy or matt; they print fine work very accurately. Coatings may also be coloured inks, metallic and textured finishes.

Coating trough: A narrow trough to hold stencil emulsion is drawn up the screen from bottom to top giving an even coat.

Cobalt driers: Added to ink in minute quantities to speed drying. Used when the substrate is non-absorbent i.e. plastic.

Cockling: The UK term for wavy paper. It occurs when paper has been packaged at the mill when immature; the remedy is to spread it out or hang in the air. It also occurs when paper has been unevenly dampened.

Code numbers: Manufacturers' codes on their products can give valuable information. *See also* MSDS.

Codex: An early manuscript in a book form with illustrations.

Collage: From the French *collé* to glue or stick, used in printmaking to prepare a printing block or to assemble a print from various elements. *See also* collagraph.

Collagraph: A print, intaglio and/or relief, taken from a collaged block or plate. A backing plate of metal, board, card, plastic or wood forms the base. Materials such as cut-out shapes, found objects, organic substances can be glued to the base. Work can be drawn in glue, modelling paste, acrylic gel paste or gesso to which may be added carborundum grit, sand etc. to give tooth to printing ink. Absorbent materials must be sealed before printing, which may be intaglio and/or relief.

Collagravure: French for collagraph.

Collate: To gather together all the prints in a suite; to gather together sections of a book in the correct order.

Collograph: Synonymous with collagraph but from the Greek root *kollo* for glue. Used mostly in the US. Also, confusingly, used to describe a collotype made by an artist.

Colloid: Water-soluble gelatinous substances such as albumen, gelatine, gum arabic and dextrin used to make light-sensitive coatings with the addition of a bichromate.

Collotype: A photomechanical process, invented by Alphonse Poitevin in 1855, in which a light-sensitive gelatine (colloid) on a glass sheet is exposed and developed without the use of a halftone. Hardened areas of gelatine accept ink, soft, watery parts reject it. Usually printed on a flatbed press similar to a lithographic press. Reticulations in the gelatine give an aquatint-like texture. Developed in the late 19th century and used to print fine reproductions. Recently, printmakers have revived this almost extinct process.

Colophon: The final paragraph in a book giving details of authorship, printer, materials, size of edition etc. Still used in artists' books but transposed in mass-produced books to the imprint on the title reverse.

Colorist: *See* chromiste.

Coloritto: The name given to Le Blon's four colour mezzotint process.

Colour calibration: Digital software measures the colour profile of monitor, scanner, printer etc. against the theoretical values and corrects variations. *See also* CIE.

Colour channel: A digital image can be seen on the monitor separately ie. the red or the green etc in a RGB image or a spot colour.

Colour fading: A gradual change in the colour of paper and ink due to exposure to light and acid in paper.

Colour fastness: Printmakers aim to use inks and pigments which have the best colour fastness. The addition of extenders to inks can increase fading. Fastness was measured visually in industry using the Blue Wool Scale by exposing half a print for a measured time and comparing it to the unexposed half against a standard (BS1006) graded from eight, which is permanent, down to one, which is very fugitive; six and higher is regarded as fade resistant and lower than six will fade. The Blue Wool Scale has now largely been replaced by a new, much more accurate scale called Delta-E which is now also the international standard for colour space. After criticism of digital prints, ink manufacturers now describe the parameters of the tests they use in greater detail: type of light source and intensity, temperature, humidity and type of glass used in framing arriving at a time when fading will be noticeable. *See also* CIE.

Colour gamut: The colours that can be rendered by a printing process measured as colour space in CIE or LAB systems. *See also* CIE.

Colour modules: Computer systems for specifying colours. *See also* RGB, CMYK and HSV.

Colour print: A print using several colours.

Colour profile: A computer term for the colour characteristics of different devices which are important when translating colours between them i.e. monitor and scanner. *See also* CIE.

Colour proof: A proof taken to check position and colour prior to editioning; used to try out different colours and the sequence of printing order.

Colour saturation: Strength or intensity of colour.

Colour scanner: An electronic device which digitally records a colour image.

Colour separation: Where an image is analysed into a number of colours for printing either as one colour per block, plate, screen or photographic film or a drawn guide for separate areas of colour on one printing matrix or for a reduction print.

Colour space: A spherical theoretical model for defining colour values. *See also* CIE.

Colour strength: In printing ink or paint the concentration of pigment per volume.

Colour stretch: Used in lithography to describe the range of tones a given colour can print, i.e. black will print a wider range of tones than yellow.

Colour swatch: A collection of colour samples kept for matching. Ink is dabbed out on a piece of paper to compare with the master proof or image or to be kept as a record.

Colour transparency: A colour photograph on a transparent support.

Coloured print: A print, often monochrome, to which colour has been added by hand or stencil, usually watercolour.

Colourizing: A form of digital proofing where each colour layer is printed on film and then laid on top of each other.

Columbian press: An American cast iron platen press first made in 1813, later made in Britain. Highly prized by printmakers. Similar to the Albion but characterised by its extravagant decoration.

Combination press: A modern roller press with an adjustable bed height so it can be used for relief and intaglio printing.

Combination print: *See* hybrid print.

Composing: The setting of units of metal or wooden type in order, hence compositor.

Composing stick: A metal device to hold type in order while assembling it in a line.

COMPOSING STICK

Compound print: An early 19th century term for for a multi-coloured relief print from metal similar to a jigsaw print.

Compression: Computer term for the reduction of file size by JPEG which gives some degradation of the image or LZW with little degradation.

Computer print: *See* digital print.

Computer to plate: Digital offset lithography automatically makes printing plates using blue laser scanners bypassing photography or reprographics.

Concertina binding: A Japanese binding style used for artists' books as an alternative to binding pages together. One long sheet of paper is

folded on each page edge and the ends are glued to cover boards. Also known as *leporello*.

Condensed types: A narrow typeface design.

Conditioned paper: Where the paper is at the same humidity and temperature as the workshop, often necessary when a packet of paper is first opened.

Congreve print: See compound prints.

Contact paper: A trade name for sticky-backed vinyl sheet which can be used to back etching plates instead of a varnish resist. Other common brands are Fablon and Fascal.

Conté crayon: A grease-free red earth crayon which can be used to mark lithographic stones and plates. In powder form it is used to dust a sheet of thin paper for use as a non-greasy tracing paper; also the trade name for brown, red or black drawing chalk or crayon.

Continuous tone: The smooth gradation from light to dark rendered by variable density as in a photograph; where tone is created by random reticulation in collotype, random dot screen in stochastic printing, aquatint in intaglio and

random grain texture on lithographic stone and plate. *See also* diazo lithography. True continuous tone occurs only in the Woodbury-type process.

Contone: A photographic and computer term for continuous tone.

Contone film: Large format continuous tone films for photography and photo-mechanical processes; are becoming difficult to find.

Cooking oil: Cheap cooking oil is widely used to soften inks when cleaning up in place of toxic solvents. After the oil, finish with liquid detergent and drying.

Copal: A hard tree resin used in varnishes and very hard lithographic crayon.

Copper (Cu): Old copper plates were somewhat harder than those made today due to the inclusion of impurities and the fact that the metal was beaten flat rather than rolled. Copper used today is available as hard, half hard and soft; half hard is standard for etching. Thickness was measured in SWG (Standard Wire Gauge) but more recently in millimetres. 22 SWG (thinnest) to 14 SWG (thickest) is used but 18 SWG or 1mm is the popular thickness for intaglio.

Roofing copper has been recommended because it is cheaper but buying standard copper in bulk and looking for pre-polished with a film protected surface is as economical. British 22 gauge is equivalent to US .028in., 0.71mm.

Copper flashing or facing: Intaglio zinc plates are copper-faced electrolytically when yellow ink is to be used as it discolours to green. Copper discolours coloured inks too so steel facing is generally preferred. *See also* steel facing.

Copperplate: General term for all intaglio plates and prints taken from them, a copperplate press is a an intaglio press.

Copperplate oil: Cold pressed linseed oil prepared in different viscosities: light is slightly burnt, medium is more burnt, heavy or thick is burnt to a sticky consistency.

Copy camera: Used to copy art work or photographs for processing in any photo-printmaking system. It is now commercially superseded by image setters and linotronic output.

Copyright: The print copyright belongs to the publisher, who may also be the artist, unless otherwise agreed. The idea (rather than finished print) belongs to the artist and is known as intellectual property.

Cork print: Relief print made from engraved cork blocks have a characteristic speckled printed surface.

Cornelius solution: Trade name for a mixture of solvent, gum arabic and asphaltum used in lithography to dissolve the surface image.

COSHH: Control of substances hazardous to health regulations in the UK (first 1989).

Cotton buds: Twists of cotton wool on a stick are used to ink and clean small areas on a plate or block.

Cotton linters: Cotton fibers which are too short for spinning but are used to make paper.

Coucher: The handmade paper craftsman who lays the sheet of freshly made paper on felt to continue draining. *See also* vatman and layman.

Counter-etching: Used in lithography when new work has to be added. Acetic or citric acid is used to strip away the gum adsorb film on the stone.

Counterproof: A wet proof that is transferred to another sheet of paper; it will be in reverse.

Covercoat: A liquid thermoplastic is

screenprinted over an image on decal transfer paper. The covercoat plus the image can be slid off the paper backing and onto a ceramic support. The covercoat is burnt off during firing.

Crayon: Black and coloured, non-graphite, drawing pencils and sticks some of which are wax-based but some are also water-soluble. *See also* chalk and screen painting.

Crayon engraving: An engraving which mimics the texture of crayon by the use of roulettes and needles, popular in the 18th century.

Creeping bite: A etching technique to make a graduated tone. The plate is tilted in the acid bath which allows the acid to creep up.

Crevé: A French term for an etching where the space between closely drawn lines is over etched and lost. *See also* cross hatching.

Cristalraster: A process developed by Agfa to produce a stochastic halftone screen.

Crocus paper: *See* lustre paper.

Cross hatching: The crossing lines used to depict tone are difficult to maintain in etching as the small amount of metal between lines tends to break down.

Cross media: Works which combine more than one discipline such as print and video, print and architecture.

Crown: Paper size 380 x 508mm (15 x 20in.).

Cushion: A small sand-filled leather bag on which a metal plate or woodblock rests during engraving, The plate or block can be easily turned while engraving curved lines.

Cut: A print taken from any engraved surface, i.e. woodcut.

Cutting forms: Rectangular blocks of wood against which book covers are trimmed by hand.

Cutting plotter: A digital plotter can be modified with a cutting head and cut out vector-based images; mostly used in the signage industry.

Cyan: Turquoise blue ink which together with yellow, magenta and black make up the four-colour halftone printing system known as CMYK.

Cyanotype: Invented in 1842 by Sir John Herschel; made by exposing a negative to a paper prepared by soaking in ammonio-citrate of iron and potassium ferricyanide. It looks like a blueprint but is permanent.

Cylinder blanket: *See* felt.

Cylinder mould papermaking machine: Invented in 1808 by John Dickinson. A cylinder covered by wire mesh rotates half submerged in a vat of paper pulp, picks up and deposits a continuous web of paper which is dried and pressed. This paper, called 'mouldmade', is made from similar paper pulp or furnish as handmade paper and has a distinct directional grain along its length and only two natural deckles along the web edges, the others are torn edges. It is stronger than machine-made paper and is the most widely used paper by artists including printmakers.

Cylinder press: A press where the top roller provides the pressure; examples are the intaglio press and letterpress proof presses.

D

Dabber: Inking pad made of cloth or soft leather.

DABBER

Dab printing: A traditional Chinese hand-printing technique which allows printing from the intaglio, relief and angled cut surfaces of a woodblock. The damp paper is tamped into the cut recesses of a woodblock and colour applied on the various surfaces by a dabber or the point of a brush. It originated from the printing of engraved stone stellae. The result can be monochrome or multi-coloured and very sophisticated. *Pochoir* (*pu mo ta*, chinese) is also a form of dab printing.

Daguerreotype: A photographic image formed by a fine deposit of mercury amalgam on a polished silver surface.

Daguerreotype print: A rare print made by taking an electrotype from a Daguerreotype and printing it intaglio.

Dallastype: A term used in the 1860s for photogalvanography but later modified to Dallastint and used for a line block which uses the reticulation of gelatine. *See also* photogalvanography.

Damp box: A waterproof, shallow box containing damp blotters between which paper to be dampened is interleaved: a lid weights the contents down for even dampening.

Dampened paper: Intaglio prints are usually taken on damped paper as are most Asian water-based prints. In relief and letterpress printing, heavy papers often give a better result if dampened.

Dandy roll: A wire cylinder which has watermark designs in wire sewn on it to emboss watermarks on machine and mouldmade papers. It is also the mesh cylinder which rotates in the vat and picks up paper pulp before depositing it on the felt web in mouldmade paper manufacture.

Date: The publication date of a print which is often written in pencil below the image at the time of signing.

Dauber: US term for a dabber.

Decal: A printed image which can be transferred to another surface; usually refers to a 'waterslide' transfer.

Decalcomania paper: Trade name for coated paper used in transfer lithography and for the transfer of photocopied and laser printed images. Also used to transfer a printed image onto a ceramic surface.

Descenders: A typographic term for that part of the letter below the x-height i.e. g, j, p etc. *See also* ascenders.

Deckle: The rectangular frame used with the mould which holds the required amount of pulp in handmade papermaking. The thin, irregular edge of a sheet of handmade paper, called the deckle, is made by pulp seeping between the deckle and mould. It can also be made artificially in imitation of hand and mouldmade papers.

Deep etch: In etching where the non-image areas are etched to a great depth or even right through the plate.

De-greasing: Many printing surfaces need to free of grease to make them receptive to further processing. De-greasing agents are mildly alkaline and include such substances as soap, ammonia, methylated spirit (denatured alcohol) and domestic cleaning products.

Delineavit: Latin for 'he drew', abbreviated to delin., delt., del.; seen on old prints.

Demy: Paper size approximately 444 x 571mm (17$\frac{1}{2}$ x 22$\frac{1}{2}$ in.).

Denatured alcohol: US term for methylated spirit. Denaturing refers to the addition of blue dye to make it unpalatable.

Densitometer: A device to check the emulsion density of developed photographic film in order to check the tonal values.

Dental plaster: Used in some lithographic transfer paper coatings and it is also used to take casts. *See also* plaster prints.

Depôt legal: French term for the compulsory deposit of prints i.e. Bibliotèque Nationale in Paris.

Derby print process: A form of screenless continuous tone offset lithography developed after 1915 by the printers Bemrose and Sons, Derby.

Dessiné: French for 'drawn by' seen on old prints.

Detergents: Used as de-greasing agents.

Develop: Chemical process to fix a photographic image on paper, plate or screen.

Dextrin: A water-soluble gum derived from wheat or maize starch used as an adhesive. Also called British gum.

Diapositive: A photographic transparency.

Diazo: A group of light-sensitive compounds which have replaced ammonium and potassium bichromate; applied to paper, plastic or metal plates.

Diazo lithography: An image drawn on grained transparent film and exposed to positive-working diazo plates is broken into minute particles by the grain on the plate and the film giving a continuous tone effect without the use of a screen.

Dichromate: The same as bichromate. *See also* potassium bichromate.

Didot point system: European typographical measurement: 12 points = 4.511mm.

Die cutting: Sharp metal strips are bent and fixed to a base to cut paper and card into shapes; used by some book artists making pop-up books.

Die stamping: Embossing using two metal plates, one relief and one intaglio, which mould a sheet of paper between them. It is often used for cards and letter headings using an ink in the intaglio.

Digital camera: Images are stored not on film but digitally so they can be downloaded into a computer.

Digital collotype: The application of digital techniques to the image formation on collotype plates.

Digital engraving machine: Digital information can drive a direct engraving head which cuts into metal or other material such as wood and plastic for intaglio and relief matrices. *See also* vector engraving, raster engraving and CNC cutting.

Digital halftone: Two kinds of computer-originated halftone can be made: AM (amplitude modulated) which are on a grid similar to photographically-screened halftones and FM (frequency modulated) which use random patterns similar to continuous tone.

Digital image: A pixel-mapped or vector image.

Digital output bureaux: Commercial companies who offer digital scanning and will transfer digital images direct to high resolution film from disk or digital camera using an image setter.

Digital print: A print which has been created all or in part using digital equipment.

Dimensional stability: Paper or film which is not distorted by environmental changes such as humidity which is very important when many colours are being printed.

DIP PEN

Dip pen: A pen for drawing or writing with a nib which is dipped in ink.

Direct emulsions: A light-sensitive screen emulsion is coated directly on the screen which is then exposed and developed.

Direct/indirect emulsions: A light-sensitive stencil is coated onto a plastic backing. It can be exposed and developed and it is then attached to a screen or it can be attached to a screen and then exposed and developed.

Direct lithographic press: A press where the paper is in direct contact with the printing matrix. The early direct presses gave way to offset lithography for commercial printing after 1904 but they are still used by artists for stone lithography.

Disc-shaped scraper: A circular scraper used for removing the burr on engraved plates.

Display faces: A typographic term for typefaces larger than 72 point, often made in boxwood, which were designed for use in posters and other display material.

Distribution of type: Returning type to its correct section in a case after printing, called 'dissing' for short.

Dithering: A computer process where coloured pixels are optically mixed or the edges softened.

Dithers: Tiny randomised dots are an alternative to digital halftones.

DOD: Drop-on-demand inkjet printers use four colours, CMYK and some also add RGB and light magenta and light cyan. The wide range of colours is made by different numbers of dots per inch. They are available in formats up to A0 size and with resolution up to 1440 dpi. They are not as expensive as Iris printers.

Dolly: A small pad of cloth, scrim, roll of felt or inking tampon used to dab colour on a small area of a block or plate in multi-coloured inking. *See also à la poupée* .

DOLLY

Dot gain: A term in digital printing when the dot size increases because of a special interaction between the ink and substrate.

Dot matrix printing: Electronically-controlled printing where pins strike an inked ribbon; now superseded by inkjet and laser printers.

Dotted print: *Manière criblée* (French), *Schrotblatt* (German). A 15th century technique in which a metal plate is engraved and indented with goldsmith's punches and then printed in relief.

Double: A paper size which is double the original i.e. crown is 380 x 508mm (15 x 20in.); so double crown is 508 x 760mm (20 x 30in).

Double elephant: Paper size approximately 1020 x 690mm (47$^{1}/_{4}$ x 27in.).

Double spread: Two facing pages in a book.

Double tone: A cheaper form of duotone in which the lighter tone spreads a little giving a halo round the darker tone.

Doublure: A bookbinder's term for the lining paper or leather which is pasted on the inside of the binding boards.

Down sampling: *See* resampling.

DPI: Dots per inch is the measurement of the spatial resolution of a printer or other output device. The dots are all the same size and tone but have variable distances between them.

Drafting film: Polyester film used for drawing with ink, paint, crayon and pencil etc. It is usually smooth on one side and grained or matt on the drawing side. See also textured film.

Dragon's blood: A powdered wood resin used to protect the sides of an image during etching to avoid undercutting and therefore weakening the plate during printing.

Draw down: A way of testing coloured ink by taking a small sample on a square-ended palette knife and drawing it across a sheet of paper.

Draw tool: A hook-shaped steel tool with a handle. The point of the hook is sharpened and it is used to cut metal plates by scribing the metal until it can be bent and snaps.

DRAW TOOL

Drawn-on cover: A square-backed binding which is glued to the back of a book.

Driers: An additive to inks to speed drying. They are in paste form consisting of a resin plus a metal, usually cobalt, lead or magnesium. Minute quantities are generally only mixed in just before printing.

Drop brush: A brush used for dropping colour in a specific area.

Dropping out: In intaglio colour printing where very pure colours are required in certain areas, they can be etched or cut out of all the plates except the specific colour plate. This

avoids the other plates printing even a very thin film of unwanted colour.

Dry brush: A technique where distinct brush marks are required using ink, tusche or paint. The vehicle (water, oil etc.) should be almost dry to retain the brush marks. Also called scumble.

Dry gum paper: A lithographic transfer paper with a mat coating for use with crayon, pencil and tusche drawings.

Dry lithography: *See* waterless lithography.

Dry offset: *See* letterset.

Dry pigments: Powdered pigments which are mixed with various vehicles to make printing inks suitable for different forms of printmaking.

Drying boards: Porous boards which let moisture escape when drying prints.

Drying cabinet: A dark, heated cupboard in which coated screens are dried horizontally.

Drying-in: In screenprinting, when the ink starts drying around the edge of the image areas giving a fuzzy perimeter and loss of crisp detail.

Drying prints: Prints taken on dampened paper must be dried flat when the last colour has been printed. Intagio prints can be left to dry and later re-damped and then pressed. See also flattening.

Drypoint: *Point seché* (French), *Kaltnadel* (German). An intaglio engraving technique where the image is drawn on the metal or plastic plate surface using a hard point called a drypoint needle. Sealed card or card with a plastic finish can also be used for drypoint and is strong enough to yield a few prints. The action of the needle throws up a burr either side of the line which holds the ink giving a characteristic velvety line. *See also* burr.

Drying rack: An apparatus for drying prints flat in large wire trays hinged at the back edge in tiers.

Dry roll: In lithography when the stone or plate dries out and ink adheres to the non-image areas.

DTP: Desktop printing, a general term for the use of a computer to lay out type and images. Widely used to make artists' books.

Duograph: *See* duotone.

Duotone: A monochrome photograph is screened twice

(turning the screen for the second exposure to avoid dots overlapping). These can then be printed by letterpress, lithography or screen using two monochrome inks, one lighter than the other giving the effect of depth and richness.

Durometer: A US measure of hardness in inking rollers, squeegees and flexographic plates; called shore in UK.

Durst Lambda print: A digital system which prints directly onto photographic paper.

Dust bag: A textile bag holding resin dust for the hand application of aquatint. Silk is used for the finest dusting, cotton for medium and hessian (burlap) for a coarse texture.

Dust box: Also called an aquatint box. Powdered resin or asphaltum is agitated by means of a hand-turned fan; the metal plate is inserted and the dust slowly settles on the plate

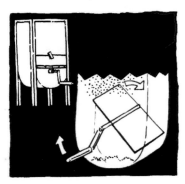

DUST BOX

which can then be heated to melt and fuse the aquatint on the plate in a random pattern.

Dutch mordant: Acid used for etching copper made from 2% potassium chlorate ($KClO_3$) and 10% hydrochloric acid (HCl); first used about 1850.

DVD: Digital versatile disk; is similar to a CD-ROM, a more recent development.

Dwell: A bookbinder's term for the length of time a heated tool is pressed into gold when tooling or blocking.

Dye: A solution of fine pigment particles dissolved in a binder and always in suspension. Used to colour paper, in inkjet printers, and making DIY screen inks cheaply. Colours may not be as fast as pigments.

Dye line: Similar to blueprint.

Dye resist: Any oil-based ink or paint which is printed and then overprinted with water-based dyes.

Dye sublimation printer: A digital device using solid dye-based inks which are converted to gas and then solidify on contact with a substrate. Close to continuous tone quality.

Dye transfer: A type of colour photographic print giving rich, brilliant hues; more permanent than other colour photographs. Occasionally used by artists.

E

Eauforte: French for nitric acid, literally 'strong water', also a general term for all etchings.

Echoppe: An etching needle with a sharpened, flat, oval end used to draw imitation engraved lines on a hard ground.

ECHOPPE

Edinburgh etch: An etching solution of ferric chloride and anhydrous citric acid powder developed by Friedhard Kiekeban, 1997, at Edinburgh Printmakers and used to etch zinc, copper, steel, brass and aluminium.

Edition: The declared number of prints published, not including artists' proofs and other proofs. There is no further printing of that image. *See also* cancellation.

Edition de luxe: Part of an edition which is specially treated by being printed on a superior paper or more usually being bound or housed in a luxurious portfolio.

Editioning: The printing of the edition once the passed-for-press proof is obtained. In reduction prints the proofing and editioning are combined.

Editor's proof: A final print, identical to the edition, is reserved for the editor who has organised the publication of an image or suite of images; somtimes the same person as the publisher.

Einblatt drucke: German for the Japanese single sheet print. *See also Ichimai-ye.*

Electroetch: An electrolytic etching system patented by Imre and Marian Behr in 1993 in the US.

Electrotype: A metal duplicate printing plate made by the electro-deposition of copper of an original wood engraving, linocut or delicate type when the run is long and the image would breakdown during printing. It was developed in the 1840s. The copper is backed by a lead alloy for strength.

Electrolytic etching: An etching process where an electrical charge is passed from an anode attached to a printing plate of the same metal as the anode and suspended in a weak acid bath or electrolyte (copper sulphate for copper plates). Metal is etched from the plate where it is not protected by an acid resist such as varnish, wax, thick printing ink or aquatint.

Electrostatic printing: Photocopying and laser printing process where the image is formed in electrical charges which attract toner particles, these are then transferred to a substrate and fixed by heat.

Elimination print: *See* reduction print.

Elliptic graver: US term for a wood engraving tool. *See also* spitsticker.

Em: A UK and US typesetting unit of measurement, also called a pica. One em =12 points ($^{12}/_{72}$ of an inch). *See also* point.

Embossing: *Gauffrage* (French), *Blindrucke* (German), *Karazuri* or *Kimekoni* (Japanese). A deep impression on damp paper which is three-dimensional. Blind embossing is when the printing block or plate has not been inked.

Emulsion: Light sensitive coating on photographic paper, film or printing matrix.

En: Half an em or six points. *See also* em.

End grain: A block of hardwood cut across the trunk, showing the growth rings. End grain is used for finely worked blocks such as wood engravings.

END GRAIN

End papers: Decorative sheets of paper at the front and back of a book next to the cover.

Engraver's charcoal: A block of fine charcoal used to polish metal plates.

Engraving: An image cut into metal plate (without the use of acid), wood, lino or other material by means of tools such as a graver, burin, knife, gouge, drypoint needle and electrical craft tools. It is also a general term for an incised mark, an incised block or print and even a general collective for all artists' prints.

Engraving machine: *See* ruling machine.

Epoxy resin: A strong adhesive resistant to chemical attack.

Epreuve d'artiste: French for artist's proof; shortened to EA.

Epreuve d'etat: French for a state proof. *See also* state proof.

EPS: Encapsulated PostScript is a computer file for storing vector images.

Epsom salts ($MgSO_4$) (Magnesium sulphate): Sprinkled on wet tusche wash in lithography to create a pattern of dark rings around each crystal; cooking salt gives a similar effect.

Esparto grass: Used to make some papers; it is usually mixed with other fibres.

Estampe: French general term for an intaglio print. Also used to designate a print where a copyist has made the printing matrices after an original by another hand, similar to the chromiste in lithography. Sometimes also used to describe a print which relies on embossing.

Estampe de tirage limité: French for an *estampe* print issued in a limited edition which may also be signed by the original artist.

Estampille: A run-on print, extra to the edition, not usually signed. Sometimes used to describe a print with much embossing.

Estate print: A print issued after the artist's death either by the family or trustees. Usually distinguished by a special blind stamp or chop mark.

Etch or etchant: The mordant, acid or alkali, used to bite a metal plate; also the mixture of gum arabic and nitric acid used on lithographic stones and plates to process the image.

Etched linoleum: A lino block etched by a strong alkali such as caustic soda solution or paint strippers.

Etching: *Eauforte* (French), *Radierung* (German). An image bitten into a metal plate by acid. Also the processing of a lithographic stone or plate in preparation for printing.

Etching ground: The acid-resistant coat of wax or acrylic copolymer on a metal plate through which the design is drawn or impressed.

Ethanol (C_2H_5OH) (Ethyl alcohol): Rubbing alcohol. Used as a solvent and, diluted with water in a spray, to laminate photopolymer film to a bearer plate.

Eucalyptus oil: Used to clean the press bed.

Ex. coll.: Latin for 'from the collection of... Used to establish the provenance of a work.

Excudit: Latin for issued or published, follows the name of the publisher on old prints.

Exposure unit: In photo-based printmaking a light-sensitive surface is put in contact with a negative (or positive) on a vacuum bed and is exposed to a light source. Used to make photostencils, photolitho plates, flexographic, photo-intaglio and relief plates. Hence exposure times and exposure meter.

Extended or expanded type: A wide typeface.

Extender: *See* reducing medium.

Eylet tool: A tool which punches holes in various materials including leather, cloth and paper.

F

Face: The printing surface of metal type. Also the design of a particular font.

Facsimile: A fine quality reproduction exactly the same size as the original.

False biting: *See* foul biting.

Fat oil: Pure turpentine reduced over heat and used as a printing medium mixed with ground pigments for ceramics.

Feathering: A feather is used to sweep off the bubbles which collect on a plate in some etching baths.

FEATHERING

Fecit: Latin for 'he made'; found under the image on old prints followed by the name of the engraver, etcher or lithographic artisan who interpreted the artist's design.

Felt: Sheets of felt, also known as blankets, are used in an intaglio press between the roller and printing paper. The usual number is three – five and they are made of woven or matted wool or nylon. Some artists use them all the same thickness and quality so they can be interchanged. The thinner felt, which is in contact with the roller, is called roller cloth, cylinder blanket, fronting, woven pusher or pusher felt, it absorbes the friction and protects the next felt; middle, medium, thick cushion or cushion felt. The bottom felt is called the sizing or starch catcher or soaker and is usually thinner when using fine papers or thicker where embossing is used. Thicker felts are called swan skin or swan cloth. Some open access workshops use a felt protector sheet made of Kevlar above the bottom blanket to avoid damage to all the felts; practice varies widely. In papermaking, freshly made sheets of paper are interleaved with felts which absorb excess water.

Felt side: The top side of a sheet of paper; usually the printing side; the side on which the watermark is readable.

Ferric chloride ($FeCl_3$): A corrosive salt also known as perchloride of iron. It comes in lump, granular anhydrous or liquid form. In diluted form it is used to etch copper and with some additions, to etch zinc. It is recommended as less toxic and dangerous than nitric and other acids.

Ferric nitrate ($Fe(NO_3)_3 \cdot 9H_20$): The mordant used to etch silver.

File: A computer term for a set of data.

File format: A computer term for storing digital information of different kinds: TIFF and JPEG formats for pixel-mapped images, EPS for vector based images and DXF for 3D models.

Filigrane: French for watermark.

Fillers: Thick liquids or solids which are used to fill the spaces between threads of screen meshes. Most commonly PVA-based but they may

be cellulose, oil- or water-based or crayon, glue or powder (talc, French chalk or fuller's earth, a type of clay).

Fillet: A strip of wood or other material used in a picture frame to produce a space between the image and the glass.

Filling in: Where ink inadvertently extends into a non-image area of a printing matrix; in intaglio when a finely worked area breaks down; in relief when the non-image area is not deeply enough cleared; in lithography when the non-printing area is under-etched or over-inked and in screen when the stencil breaks down.

Film density: Measures the opacity of the black areas of a film image. *See also* densitomoter.

Filter paper: Unsized paper made for filtration which is suitable for relief printing. It was originally made from pure rag paper but today it may be made of synthetic fibres.

Fine manner: A style of engraving using small marks to create the impression of a wash, used on some early engravings.

Fingers: *See* paper grips.

Finishing press: A wooden screw press which holds a book sideways so that many processes can be carried out on the back or spine.

Finishing tools: A group of bookbinder's tools which produce lines, dots and decorative patterns on a binding.

Firewire: A computer term for a high band width connector for rapidly transmitting large amounts of data between devices, especially digital video.

Flag fan: A simple, hand-held flag-shaped revolving fan used to dry lithographic stones and plates.

FLAG FAN

Flash point: The temperature and concentration at which solvents give off vapour and can ignite.

Flat: A solid area of colour. Also when a roller has been left unsupported so that one side becomes flat.

Flat bed: A type of press with a flat, horizontal bed on which the printing matrix is placed. Examples are the direct lithographic press, intaglio, relief and collotype presses.

Flat bed plotter: Vector-based digital images are drawn by a pen on paper placed on a flat bed. A steel needle can replace the pen and draw through a hard ground on a metal plate for etching.

Flattening: Paper which has been dampened for printing must then be flattened to prevent cockling. This is usually done during drying by interleaving each print with acid-free tissue and inserting an absorbant blotter between each print or small group of prints. A pile is then weighted down. The blotters, which may be blotting paper or thicker boards, are changed each day until the paper is dry. Large studios may have hot air drying systems.

Flax: A plant fibre (*linum usitissimum*), in the form of rags, was the principal constituent of paper. The collection of rags was a considerable industry, they were then sorted, cleaned, cut up and beaten to make paper pulp. New flax fibre is now being used to make paper.

Fleuron: A printer's ornament. *See also* flowers.

Flexography: Lineblock or halftone made from rubber, plastic compounds or photopolymers, cheaper than metal. Widely used in commercial packaging printing but also used by artists. Sometimes called 'flexo' but more commonly called photopolymer intaglio or relief. *See also* analine printing.

Flocculation: In lithography, ink can absorb water which has the effect of separating the solids in the ink into clumps and it looks spotty.

Flock: Powdered wool or other fibres are glued to a block surface which will then hold dilute inks and dyes when printed on textiles.

Flock print: A 15th century technique where an image is printed with glue and flock is dusted over it giving it a velvety texture. Occasionally used by artists today but technically updated so that synthetic fibres are fired from a gun onto a printed sticky surface.

Flong: First used in 1829, *papier maché* or a plastic/rubber mixture is used to make a mould from existing type, relief or intaglio plates. The metal cast from the flong, called a stereotype or stereo, can be printed letterpress. Common practice when a long run would have worn down a wood engraving or founders' type. Both flong and stereo can be pressed

into a soft ground and etched.

Flooding: The first stroke of the squeegee in screenprinting is away from the printer. This deposits an even coating of ink into the mesh (also called charging), followed by the printing stroke towards the printer's body.

Flour: Wheat flour is used to make a paper paste to attach *chine collé*, paper hinges and as an alternative to rice paste in Japanese water-based printmaking.

Flowers: Decorative type units in point sizes used to set ornaments and borders.

Fluorescent inks: A group of inks which absorb light and re-emit it.

Fluting: A way of shaping paper in a series of undulating waves.

Flutter book: A Japanese style of binding in which the paper is concertina (or accordion) folded but the cover, front and back, is in one piece and each end of the folded pages pasted to half the cover. When opened, the pages 'flutter'.

Fly leaves: A set of plain or decorative papers next to the end papers which provide further protection to the book pages.

Foil: Metals are deposited on a plastic film by vaporisation in a vacuum. The method was invented in 1932 to speed the mass production of book bindings. The metal is transferred to a book binding by hot stamping. *See also* blocking press.

Folding tool: *See* bone.

Folio: A sheet of paper folded in two. Also the page number in a book.

Font: The complete set of any type design including upper and lower case, small caps, roman and italic, punctuation and numerals. Also called the fount.

Foot: The bottom edge of a book.

Foot notes: Notes at the foot of a book page set two sizes smaller than the text type.

Footer: Type which appears at the foot of each page including the page number.

Foredge: The front edge of a book, opposite to the binding.

Formalin: A few drops are added to rice or wheat paste to keep it fresh and extend its life.

Format: The size of an artist's book or a print.

Forme: The metal frame in which type and furniture is locked ready for printing.

Formed paper print: See cast paper print.

Formschneider: German for an artisan who cuts a woodcut or engraving following an artist's design.

Foul biting: When an intaglio ground lifts off because the acid is too strong or the ground was not well applied. It gives a grainy texture and some artists use it deliberately.

Founders' type: The more unusual typeface designs bought ready-cast from a licensed typefounder i.e. not available as matrices for casting on Monotype or other casting machines. *See also* Monotype.

Fountain solution: A mild etch added to lithographic dampening water to prevent scumming; in automatic presses the water duct is called the fountain.

Four colour process: The usual method of colour reproduction whereby a full range of colours is suggested by the opitcal illusion of printing in cyan (turquoise blue), magenta (red), yellow and black dots. The dot system is called halftone and is measured as so many dots per square inch (dpi). The four colours are shortened to CMYK. Four colour halftones are used by artists in screenprinting, lithography, intaglio and digital prints where a colour photograph is required. *See also* halftone.

Four-hole binding: A typical Japanese binding in which the pages and covers are stitched together on the outside through four equidistant holes.

Fourdrinier machine: In 1840 Henry and Sealy Fourdrinier perfected Louis Robert's invention in 1799 of a papermaking machine to make a continuous web of paper. It is still in use today but now sprays paper pulp on a porous surface which is rapidly dried. The majority of machine-made papers such as cartridge, book papers, wrapping and newsprint are made this way. They have less strength than mouldmade papers as the fibres are not so interlocked. The paper has a distinct grain along its length.

Foxing: Discoloured spots on paper due to a type of mildew.

Fractint: The name given by Cedric Green in 1998 to the fractal-like patterns made when a plate coated with oil-based relief ink is pressed against another flat surface; when

the two surfaces are separated, suction draws the ink into these characteristic patterns; as the ink is an acid resist, the plate can be etched.

Frame: A rectangular structure to protect a print. Also a rectangular structure over which mesh is stretched to support a stencil in screenprinting. The frame of a printing press is its structural element and supports bed, rollers, platen, scraper bar or screen. The compositor's frame contains type cases.

French chalk: A kind of steatite in powdered form used in lithography to break the surface tension on stone or plate during etching. Also used to dust a printed image on acetate or to rub into an engraved block to show up the work. Interchangable with talc.

French fold: A sheet of paper folded in four, often used for greetings cards when the paper is too light to stand up but when folded will stand.

Frisket: A metal frame hinged to the tympan on platen presses such as the Columbian, Albion and Washington. It is used to hold the printing paper in place, in register, when lowering it on to the inked printing matrix.

Fronting: *See* felt.

Frontispiece: The illustration in a book facing the title page.

Frottage: French term for rubbing either on the back of a print which is lying on an inked or an uninked block. The rubbing is done with ink on a pad in Chinese and Japanese printmaking. *See also* dab printing.

Fugitive colour: Inks which are not light fast. *See also* light fast.

Full point: A typographical term for the full stop punctuation mark.

Fungicide: Phenol or formaldehyde is added to dampening water for paper to prevent mould.

Furnish: A papermaker's term for paper pulp.

Furniture: A typographical term for the wood or metal bars used to fill out the non-printing spaces in a forme and chase. *See also* forme and chase.

G

Galley: A long metal tray which holds lines of type before it is divided into pages. Galley proofs are taken at this stage for checking.

Gallic acid: Sometimes added to anti-tinting fountain solutions. *See also* anti-tinting.

Galvanic etching: A 19th century term for electrotyping, hence galvanograph. Called Galv-etch, it is used by artists today. The plate to be etched is the anode, a plate of the same metal is the cathode and when an electrical current is passed between them, the exposed metal leaves the anode and is deposited on the cathode making an intaglio plate.

Galvanography: A form of electrotyping of drawn images. *See also* Jacquemin process.

Galvanoplasty: If a metal plate is made the cathode, metal is deposited on the exposed parts of the plate making a relief plate rather than intaglio. *See also* galvanic etching.

Galv-tone: A matt, grained surface produced on open metal etched by Galv-etch: *See also* galvanic etching.

Gambia wax: Used as a bordering material to hold acid directly on large plates.

Gampi: Plant fibre (*diplomorpha sikokiana*) grown in Japan used to make a strong, lustrous paper.

Gamut: A computer term for the range of colours available by mixing red, green and blue light (RGB), known as the additive primaries.

Gasoline: A US term for an aliphatic hydrocarbon derived from petroleum, also called petrol in UK. Used as a grease solvent.

Gathering: A bookbinding term for putting the book sections together in order before binding.

Gauffrage: French for embossing.

Gaussian blur filter: A computer device which smooths out blemishes and 'staircasing' or lines which jump in units.

GB: A computer term for a gigabyte or 1024 bytes.

Gelabrome: A type of pigment photographic print where a soft-contrast photographic print on a non-coated paper is covered with a gelatine and Indian ink mixture. When dry; it is soaked in water and then potassium dichromate, when developed, the gelatine dissolves in proportion to the silver in the photographic print leaving a low relief.

Gelatine: An animal colloid — derived from bones. Used to size paper and as an additive to watercolours to slow drying in the tube and pan. Rollers made of gelatine (clean only in paraffin/kerosene) have been largely replaced by synthetic materials. It is the basis for most non-silver photographic processes.

Gelatine-silver print: The first photographic paper that was sensitive enough to artificial light so that enlargements could be made was introduced in the 1880s.

Gelatinotype: A late 19th century process where a hardened gelatine image on a lineblock avoided the need for etching.

Gesso: A mixture of plaster of Paris mixed with glue is used as a modelling paste to make collagraph and relief blocks.

Gez.,gezeichnet: German for 'drawn by'. *See also* del.

Ghost image: The pale image from a previous print seen on lithographic stone during re-graining or on a screen after cleaning.

Ghosting: The appearance of a halo round parts of an image. *Seen* in lithography where the ink rolling technique has not been varied in direction and solid areas *seem* to have a halo.

Gicleé: French for 'to spray', initially used to describe fine art Iris prints but it is now generic for all fine art inkjet prints. The term was originally devised by some American artists but is avoided in France because of its slang meaning.

Gilder's tip: Fine hair set between two pieces of card is used to pick up and place gold leaf.

GILDER'S TIP

Gillot process, Gillotype: Patented in 1850 by Firmin Gillot, it was the forerunner of the lineblock or process engraving. The image was drawn in greasy ink on transfer paper and reversed onto a zinc plate. The greasy ink was dusted with bitumen powder which acted as an acid resist, the plate was etched to produce a relief etching.

Gilsonite: A brittle bitumen mined in Utah, USA, and used in some etching grounds.

Glass epoxy sheet: Used to make tympans on some new presses.

Glass negative print: *See cliché verre.*

Glass print: A relief or intaglio print on, thin paper stuck onto the back of a sheet of glass. The paper can be peeled off leaving the printed design which is then coloured. *See also cliché verre.*

Glass writing: *See* hyalograph.

Glassine: Thin, glazed, semi transparent paper used to interleave prints.

Glucose ($C_6H_{12}O_6$.): A natural monosaccharide which is used to make some lithographic transfer paper.

Glue: Woodworker's glue (white glue, PVA) is used to stick materials to a collaged block surface and to stick small pieces of wood or lino in places where corrections are needed. In dilute form it is used to seal collaged blocks before printing with oil-based inks.

Glue epoxy print: Another name for a collagraph where the plate has been made with glue.

Glycerine: A trihydric alcohol. Colourless hygroscopic syrup made as a by-product of soap and fatty acids. Added to dampening water in stone lithography when the minimum of water is indicated.

Glyphograph: *See* cerograph.

Gold leaf: Sometimes applied to a finished print. Other metallic leaves are used in the same way: the area is printed with varnish and leaf applied; when dry, the residue of leaf is brushed off.

Gouache: A thick water-based opaque paint used for designing and painting. It is also used today in place of some traditional pigments in Asian woodblock printing.

Gouache lift: Thick gouache paint is used instead of a sugar mixture in lift-ground aquatint. *See also* sugar lift ground.

Gouge: A steel tool used in relief block cutting; either U-shaped or V-shaped.

DICTIONARY OF PRINTMAKING TERMS

GOUGES

Goupilograph: *See* sand grain photogravure.

Grain: The direction of the long-web of machine-made and mould-made paper is stronger than the cross-web direction, important when machine printing. Also the texture of prepared lithographic stones and plates; the particle texture on photographs; the texture of aquatint, mezzotint and carborudum plates and the natural growing patterns in woodblocks.

Graining: A technique for breaking down the surface of a stone, metal plate, polyester film or plate glass surface giving it a 'tooth' to accept a variety of drawing materials. The surface is ground with a abrasive substance such as carborundum or sand either by machine or hand. It is also used to re-surface lithographic stones and plates.

Grand format: Extremely large-scale printing such as is used for billboard advertising. Also known as large format printing.

Graphite: A form of carbon which conducts electricity. In powder form it is dusted on a three-dimensionally modelled plate which is to be metal plated or electrotyped. In solid stick form, it is used for drawing and is available from very soft, 4B, to very hard, 4H.

Graphotype: A later development of glyphotype/cerograph. *See also* cerograph.

Gravé: French for 'engraved by'; seen on old prints.

Graver: A steel tool used to engrave lines on wood, metal or plastic, also called the burin. It will cut a long line at a standard depth, or by varying the depth, the line swells and diminishes.

Gravure: French for engraving. It is also used as a general word for all forms of printmaking including, sometimes, reproductions.

Greaseproof paper: This culinary paper can be used to make paper stencils for screenprinting and they will last for up to ten prints before breaking up. It is now replaced by silicon release paper.

Grey board: Similar to millboard

and Esker board, used for bookbinding.

Greyscale: Computer term for continuous tone measurement in black and white photographs divided into ten steps. Also used in colour photography to check colour balance.

Groove: A bookbinding term for the vertical space between the board and the joint or hinge which allows a book to be opened out easily.

Grotesque: An early sans serif type design.

Ground: An acid-resisting coating on a metal plate which traditionally is wax-based but may now be acrylic-based. The image is drawn through the coating to expose the metal beneath to the etchant.

Groundlay oil: A sticky oil, commonly copperplate or boiled linseed oil, used for printing on ceramics and then dusting with ceramic colours before firing.

Group print: Co-operative mural-sized prints on which several artists collaborate.

Guarding-in: A method of inserting a single leaf in a book. The leaf is cut wider at the gutter and wrapped round the back of a section.

Frequently used to insert illustrations which were printed separately.

GUI: Graphical user interface is what the computer screen shows when using an application for drawing or painting.

Guillotine: A machine for cutting sheet metal or paper.

Gum adsorb film: When gum arabic solution is applied to lithographic stone it reacts in non-image areas creating a molecular layer which is hydrophilic and ink-rejecting.

Gum arabic: A secretion of several varieties of the acacia tree. It is used in solution in lithography to desensitise and etch stones and plates. It is used to make lithographic transfer paper and acts as a binder in some water-based paints.

Gum bichromate print: Introduced in the 1850s and revised in the 1890s, it used gum arabic instead of gelatine (*see* carbon print), and added colour pigment. The gum image could be manipulated by brush before drying.

Gum coat: The very thin layer of gum arabic on a lithographic stone or plate applied before a gum etch.

Gum etch: Nitric acid in a gum arabic solution used to etch lithographic stones and plates.

Gum sponge: A sponge kept exclusively to apply gum arabic.

Gum stop out: Gum arabic used as a stencil or mask in lithography.

Gum tragacanth: A natural tree gum (*astragalus gummifera*) is sometimes used as an alternative to gum arabic. It is also used to adhere gold leaf.

Gummed paper strip: Used to mask off the non-printing area round the edge of a screen in solvent-based screenprinting. Also used when stretching paper by fixing the edges of a dampened sheet to a board to dry.

Gutta-percha: A print from a wood engraving was taken on a gutta-percha (natural rubber) sheet and stretched to enlarge the design. It was then transferred to a lithographic stone and a print from the stone was taken onto canvas and used as a guide for a painting. This method was used by John Leech in the 1860s.

Gutter: The space between two facing pages (inner margins). It is also a typographic term for the space produced when pages are imposed in a forme and the foredges fall internally.

Gypsograph: In the 1830s plaster of Paris (gypsum) was poured over a metal plate. A design was drawn through the plaster using a needle to expose the plate. Type metal was poured over to form an electrotype. It was rather shallow so non-printing areas were deepened by hand to avoid picking up ink.

Gypsum ($CaSO_4 \cdot 2H_2O$) (Hydrated calcium sulphate): A filler added to paper pulp. *See also* plaster print.

H

Hair space: A typographical term for a very thin inter-letter and inter-word space.

Half bound: A type of binding when the back (spine) and corners are covered with a material different from the sides.

Halftone: The optical illusion of continuous tones rendered by small, variable sized dots obtained by inserting a cross-ruled screen in front of a negative in a camera. Widely used in commercial printing to reproduce photographs. Also used by artists when photographic imagery is required. Today the term is also used for stochastic and other random dot screens. *See also* screen, halftone.

Halo effect: Where an oily film is seen round each printed ink area.

Hand bench: A screenprinting table for hand operating.

Hand colouring: Colour added to a print by hand.

Handmade paper: Paper is made by hand in single sheets characterised by a deckle edge all round. It has no distinct grain as the vatman distributes the fibres evenly by shaking the mould. *See also* vatman and coucher.

Hand scroll: A early form of Asian book designed to be opened and read horizontally.

Hand vice: A clamp for holding a metal plate when smoking a ground.

Hanga: Japanese woodblock print (and printing).

HAND VICE

Hangi: Japanese woodblock.

Hangito: Japanese knife.

HANGITO

Hard ground: A mixture of wax, bitumen and resin which is used to coat an etching plate as an acid resist. Alternatives are acrylic-based liquids and black printing ink.

Hardboard: Masonite is the trade name in America. Compressed wood fibreboard used as a relief block material (hardboard cut), as packing in a relief press and as a general purpose studio material.

Hardener: A sealant used to harden and protect very soft and absorbent materials on collage blocks. Boiled linseed oil is used to harden open-textured woodblocks.

Hardware: Digital equipment including the computer, monitor, printer and other peripheral devices.

HASAWA: UK Health and safety at work act (first 1974).

HAZCOM: US Hazard communication standard.

Head: The top edge of a book.

Headbands: A band of stitching at the head of a book which can be plain, coloured or decorated. False headbands are stuck on in cheap book production in imitation.

Heads-up original: An image to be scanned or a computer generated image which has particular features such as high key (bright), low key (dark), over or under exposed. *See also* colour management systems and CIE.

Heat cutting: Oxyacetylene or other gas torches can be used to cut a design into a metal plate for relief or intaglio printing.

Heliochrome: An early term for three-colour relief halftone.

Heliogravure: French for photogravure or rotary intaglio printing once widely used for magazine printing now superseded by offset lithography and digital lithography. The term is also used by artists for photoetched plates where an aquatint is used instead of a halftone screen. Literally using the sun's rays as a light source. *See also* photogravure.

Heliorelief: A process to make photorelief blocks on wood, hardboard or MDF. A light-sensitive coating is applied to the block, exposed to a negative and developed leaving a relief image which can be line or halftone.

Heliotype: Another name for collotype.

Hemp: Herbaceous plant (*cannabis sativa*) fibre added to paper pulp.

Herkomergravure or Herkotype: A method invented by Sir Hubert Herkomer RA in the 1890s to turn a monotype into an intaglio plate which could then be editioned. The monotype image was made in sticky oil paint which was then dusted with metallic powder. Fine particles stuck to thin paint and heavier particles to thick paint and when dry the plate was electrotyped.

Hexachrome: The four process colours (CMYK) can be increased to six by the addition of extra light versions of cyan and magenta which increases the colour gamut. Green and orange are also added in a version called Hifi developed by Pantone.

High end printer: High resolution computer printer.

High modulus screen: Very tightly stretched screens used in industry where precise registration is needed.

Hinges: Folded strips of paper used to hold a print in position in a mount or frame. Hinges should be made of a light, strong acid-free paper such as some Japanese papers and the gum should be of neutral pH. Hinges should be removable and leave no damage to the print.

Hoeschtype: A German collotype process used in the 1870s and 1880s. The design was analysed into five colours: red, blue, yellow, flesh and grey and each colour was analysed into five tones using the variable reticulation of the collotype process.

Hollander beater: Invented in the late 18th century by Jacob Honingh to beat and break up linen fibres from rags for papermaking. Today, it beats paper fibres in water to make paper pulp ready for papermaking; small studio-size machines are available for artist papermakers.

Holzschnitt: German for woodcut.

Hone: An eraser used in lithography to remove parts of an image, it is usually made of stone, pumice or rubber.

Horizontal reflection: Image reversal, left to right.

Hors commerce, HC: French for a print identical to the edition but additional to it used for photography, display or archives, literally outside commerce.

Hosho: A Japanese paper made from *kozo* fibre, very popular with printmakers. A large Hosho sheet is 530 x 324mm. (21 x 15in.). A machine made version is called *Kikaibosho* but it is not as absorbent as handmade. *See also kozo.*

Hot plate: A heated metal plate which may be in the form of a metal box or small metal table on which metal plates are heated for the application of grounds, aquatints or inking.

HSV: Hue, saturation and value is a computer term used to describe the colour gamut. *See also* colour modules.

Hue: Colour determined by the wave length of the light produced.

Hyalograph: A technique used in 1865 by Samuel Rogers, also known as glass writing. The design was drawn through an opaque coating on glass with a needle, like *cliché verre*. The glass negative was exposed to a light-sensitive gelatine coating on metal and a double electrotype was made from the relief gelatine plate.

Hybrid print: A print combining traditional techniques with photography or digital imaging.

Hydraulic press: A platen printing press which exerts pressure by the compression of oil (originally water). They can be very large and produce a very high pressure for embossing large prints. A simple but effective hydraulic press can be made using a hydraulic car jack.

Hydrocarbon solvents: They are present in most printing inks including lithographic, letterpress and screen inks (solvent-based inks have most but even water-based screen inks may have a little).

Hydrochloric acid (HCl) (Hydrogen chloride): Used to etch zinc intaglio plates; used in lithographic counter etch. An older name is muriatic acid.

Hydrogen peroxide (H_2O_2): It is used for developing some types of indirect photostencils.

Hydrogum: A vegetable gum derived from the *mesquite* plant, used to remove scum from zinc and aluminium lithographic plates.

Hydrometer: An instrument used to measure the specific gravity of liquids. Used in printmaking to test the strength of mordants (acids).

Hydrophilic: Attracting water.

Hyphen: A typographic term for a short rule indicating a word break at the end of a line or where two words are joined in meaning.

I

ICC: International colour consortium (leading digital manufacturers) met in 1993 to standardise digital colour systems for different applications and to produce colour standards for commercial digital prints.

Ichimai-ye: A single sheet Japanese print.

IDE: Integrated development environments are used in advanced digital programming by artists.

Image: The design or visual elements of a print.

Imagesetter: A digital thermal or laser device which produces high resolution black and white images at 2400 dpi or more.

Impasto: Three-dimensional print surface produced by a deep-bitten intaglio plate, a heavily structured collagraph plate or a form of lithographic printing.

Impermanent resists: An intaglio resist which is chosen to be broken down irregularly during biting to give a lively mark. Diluted bitumen varnish, wax crayons and some felt tip pens can be used.

Imperial: Paper size approximately 560 x 760mm (23 x 30in.). The size can vary from mill to mill.

Imprint: The name and address of the printer as required by Act of Parliament for commercial printing.

Imposition: In letterpress book printing the page formes are arranged in correct order together so when the sheet is folded and trimmed the printed pages are in order. The same thing is done with negatives or positives in photomechanical printing.

Impression: A print or proof. Also the pressure applied to transfer ink from matrix to substrate.

Impression mark: A faint indentation seen on some lithographs when the stone or plate is smaller than the printing paper.

Impressit: Latin for 'printed it'; seen on old prints.

Incidebat: Latin for 'incised'; seen on old prints.

Incunabula: Latin for those early European printed books produced from the invention of moveable type, approximately 1454 up to 1500.

Indexed colour image: In digital images each pixel has an index which refers to the RGB colour in the colour look-up table (CLUT) which is limited to 256 colours; this is generally insufficient for continuous tone.

India paper: *See* China paper.

Indirect letterpress: *See* letterset.

Indirect stencils: A group of light-sensitive stencils made first and then applied to the screen. They have a polyester backing which is peeled off after exposure and development and are applied wet to the screen.

Indent: A typographic term for setting the beginning of each new paragraph one em in.

Infusion line: A fault line running through a lithographic stone which will, sometimes, print differently.

Initial letter: A large capital letter, often decorative, used at the beginning of a chapter.

Ink: Pigments mixed with vehicles to make them suitable for different methods of printing.

Inking: The application of ink to the printing matrix by roller, dabber, scraper, brush or squeegee.

Inkjet printer: A computer printer which sprays tiny ink droplets onto the substrate. Bubble jet printers use heat expansion to create the pressure, piezo electrical charges drive others. They give near continuous tone quality.

Inkjet, solid: An inkjet printer which uses solid wax sticks of ink which are melted and sprayed on to a transfer drum. Resolution is about 850 x 450 dpi, not very permanent but brilliant colours and up to A3 size.

Ink knife: A steel knife of spatula or wedge shape used to mix ink.

INK KNIVES

Ink photo: A process developed in the 1880s where a photograph on gelatine was transferred to a lithographic stone or plate instead of collotype plate utilising the same reticulation principles to obtain continuous tone. *See also* carbon tissue.

Ink slab: A non-porous slab of glass, stone, plastic or metal used to roll out ink.

Ink table or station: The area of the studio kept for ink mixing and rolling.

Input devices: Computer keyboard, mouse and scanner.

Inomache: *See nacré.*

Insurance copy: Some print publishers have an extra copy or two printed in case an edition copy is damaged; a recent practice adopted by some mail order print publishers,

Intaglio: From the Italian to incise and engrave a design cut into a surface.

Intaglio press: A sturdy metal cylinder press which can exert pressure of about five tons per square inch which sucks out the printing ink in the incisions of the intaglio plate and deposits it on the substrate. Also called a copperplate or an etching press.

Intaglio print: A print from an incised surface where the ink lies in the incisions and not on the surface. The following are all intaglio prints: etchings, engravings, aquatints, drypoints, mezzotints all of which may be in combination on the same plate or only one or two i.e. line etching with aquatint, soft ground etching with drypoint.

Intaglio silicone rubber print: A means of printing very large intaglio plates without a press. The plate is inked and a silicone rubber cast taken. All the nuances of the colour and plate are transferred. These very large prints are suitable for mural installations.

Integrator: A photoelectric cell is used to check that a light source is the same each time when repeated.

Internal hard disk drive: The computer's permanent memory where software and image files are stored. Artists need at least five GB.

Internal sizing: Size is added to paper pulp before sheet formation.

Interpolation: When a digital image is enlarged by increasing the number of pixels; they are computed from existing pixels and interpolated.

Interrupted wash-out: The intermediary stage in developing a

flexographic or photopolymer plate. The under-exposed polymer is washed away to the depth of a relief or intaglio plate, it is then exposed again to harden the remaining polymer ready for printing.

Invenit: Latin for 'designed it', seen on some old prints followed by the artist's name.

Iris printer: The trade name for a continuous inkjet printer which can produce 16 million different colours by overlaying CMYK because each dot can be varied in size up to 32 droplets (called the apparent resolution).

Iron perchloride: *See* ferric chloride.

Isinglass: Fish glue, a form of gelatine, used in some early photomechanical print processes.

ISO: International Standards Organisation measurement for the metric weights of paper is shown in grammes per square metre, gsm or gm^2. ISO standard sizes for printing; paper size starts at A0 which is 841 x 1189mm, A1 is 594 x 841mm, A2 is 420 x 594mm and so on.

Isopropyl alcohol: An aliphatic hydrocarbon made from pine oil and gum ester or castor oil. Used to make cellulose gum solution in lithography.

Itabokashi: A Japanese technique for printing a gradated colour in which the block is shaved to a slope to soften edges.

Italic: A style of type design which slopes to the right, also called slanted. It is used for emphasis, foreign words and the titles of books, pictures and other works.

J

Jacquemin process: A form of galvanography where a drawing made with lithographic ink dissolved in albumen and water was made on metal. It was heated to coagulate the albumen which made the ink insoluble. It was then electrolytically etched.

Jaz: A Jaz drive for a computer copies work from the hard disk and stores it on a Jaz cartridge. Similar to

a Zip but stores one or two GB which is useful for very large image files.

Jésus: A French paper size approximately 500 x 720mm (22 x 28 in.).

Jigger: An open-ended box kept beside a hot plate so that an inked-up intaglio plate can be slid onto it if it gets too hot or for the final wiping.

Jigsaw: Blocks or plates are cut up, inked separately in different colours and re-assembled for printing.

Jordantype: An early name for electrotype.

JPEG: Joint photographic experts group is a computer file for storing image files very compactly but it is avoided by artists as it uses a lossy form of compression.

Justification: A typographic term for the spacing out of words to fit a given column width. Columns can also be justified left side only or right side only leaving the opposite edge uneven and without breaking any words.

Jute: A natural plant fibre from Bengal sometimes added to paper pulp.

K

Karazuri: A Japanese term for embossing.

Kento: Japanese registration system where lay marks are cut into the edge of the block and printing paper is laid to them. They consist of an L-shaped corner and one long strip at the bottom or side. This system is also used by Western relief printmakers.

Kentonomi: A Japanese chisel for cutting registration marks.

KENTONOMI

DICTIONARY OF PRINTMAKING TERMS

Kerosene: An aliphatic hydrocarbon distillate of petroleum. Also called paraffin, coal oil and gasoline. It is used as a low cost grease solvent to clean up ink slabs, knives and synthetic rollers.

Keyboard: Computer typing array on which information and commands are entered.

Key image, block or plate: In colour printing it is the printing matrix having the most work, the outline or the part of the colour separations which pull the whole image together; either printed first or last. A key image can be made and not printed but used only to transfer to other matrices to ensure registration.

Kikaibosho: See *hosho*.

Komasuki: A Japanese round gouge.

Kozo: Japanese plant (*broussonetia kajinoki sico*) fibre used in papermaking. Also called the mulberry paper tree.

Kraft paper: A tough brown wrapping paper which is also used in bookbinding.

Kyokushi: A Japanese paper made from *mitsumata* which is internally sized and though rather too hard for woodblock printing, is good for wood engravings.

KOMASUKI

L

LAB: See CIE.

Lacquer: Traditionally made from shellac dissolved in alcohol which is rubbed or painted onto surfaces to make them waterproof. A synthetic lacquer is used in plate lithography to provide a tough image surface.

Lacquer thinner: A powerful synthetic lacquer solvent.

Lactol spirits: A grease solvent.

Laid down: A lithograph drawn on transfer paper is 'laid down' or transfered to a stone or plate.

Laid paper: The earliest European handmade paper shows laid lines running the length of the sheet, Chain lines run crossways; these are made by the binding wire or thread holding the laid wires in place on the mould. The impression of these wires can be seen as lighter lines when the sheet is held up the light. The effect is reproduced on machine-made paper by a dandy roll. *See also* wove paper.

Lake: A pigment made by dissolving vegetable dyes in water and fixing the colour to a transparent white powder such as gypsum. They are not very colour fast.

Lamp black: Soot or carbon is the main ingredient in black inks.

Lap marks: Uneven rolling of ink onto the printing matrix shows when printed as lines of thicker ink.

Laser films: Translucent polyester films used with thermal laser printers to produce cheap photographic stencils

Laser imaging: Red, green and blue lasers transfer digital images directly onto large-format photographic colour substrates.

Laser printer: A computer printer in which a laser beam transfers an electrical charge on to a drum which then passes through a powdered pigment which is transferred to the substrate where it is fused with heat. Four passes transfer CMYK in turn or may deposit the toner on an intermediary surface first. Typically 600-1200 dpi; A3 and A4.

Laser transfer paper: Similar to ceramic transfer (decal) paper but made specifically to withstand the heat in a laser printer.

Lavender, oil of: Added to molten intaglio hard ground and used when cold in paste form rolled onto a cold previously bitten plate; it will not fill bitten lines so areas can be re-etched.

Lavis lithographique: A lithographic wash developed in France in 1832, characterised by fine reticulations.

Layer: A digital image can be thought of as a plane rather like a sheet of acetate.

Layman: The third member of the handmade paper team who takes the newly formed, partially drained, sheet of paper from the first felt, interleaves it and adds it to a pile of sheets for pressing and drying. *See also* vatman and coucher.

Lay marks: Also called register marks. They are made on the press bed or base sheet to indicate the position of a block or plate. They are also used to show the position of the paper. They can be drawn, indicated with strips of tape or card fixed on the bed or base sheet. *See also Kento* where the lay marks are integral to the block.

Layout: The plan for a typeset design showing all the measurements, type, rules, illustrations and other features for a complete page.

LCD: Liquid crystal display is used as the light source instead of a laser in some printers.

Leading: Strips of lead rule used between lines of type: 1 point, $1\frac{1}{2}$ pts, thin lead, 2pts, middle lead, 3pts, thick lead. The term is now also used in computer typesetting to mean the space between lines.

Leaf: A sheet of paper which is printed both sides.

Leather: Fine leather can be printed intaglio or relief and it takes embossing well.

Leather shavings: Used to clean intaglio plates in the past.

Leather strop: The undressed side of a piece of leather used in the final

sharpening and smoothing of metal tools.

LED printing: Light emitting diodes used instead of a laser in some printers.

Legend: *See* caption.

Leimtype: A late 19th century lineblock process using hardened gelatine as the printing surface omitting etching. *See* gelatinotype.

LEP: Light-emitting polymers are being developed as alternatives to printing on substrates.

Leporello: *See* concertina fold.

Letterpress: Surface (relief) printing from metal type and process engraved blocks. Now no longer commercial except on a very small scale but treasured by the private press movement and artists' book makers.

LETTERPRESS

Letterset: Offset letterpress where the inked image from type and process blocks is doubly transferred by offset cylinders; the printing speed can be increased. Several separated areas of colour can all be transferred to the final impression cylinder so the paper only goes through once. The effect looks like offset lithography.

Level: The uniform thickness of any printing matrix is essential when printing with a machine.

Levigator: A circular tool made of heavy metal used with an abrasive powder and water to re-grain lithographic stones; it can be hand-held or mechanical.

Lift ground: *See* sugar lift.

Lift-off: A blotting technique used with lithographic tusche or an acid resist where a sheet of paper is lowered onto the surface then lifted taking with it some of the liquid ink or resist. Also used to lift-off excessive ink from a print all over or in selected areas.

Light: The major source of ink fading and paper becoming discoloured and brittle. Direct sunlight should be avoided when siting framed prints or any works on paper. A light typeface design is one which is a thinner version of a standard weight design. *See also* bold.

Light box: A flat box containing a light source (usually colour matching fluorescent tubes) with a frosted glass or plastic top used for checking film and for tracing.

Light fastness: *See* colour fastness.

Light-sensitive coating: Chemicals which react to light by hardening in exposed areas are coated onto paper, glass, metal and screen meshes. These produce an acid resist for intaglio and relief; a grease-attracting surface in lithography and a screen mesh sealer in screenprinting.

Light source: The sun, photoflood, mercury vapour, quartz halide, metal halide and sun lamps are all used in photo-based printmaking.

Lighter fuel: A petroleum-based liquid generally used in cigarette lighters, also called white gas. Printmakers use it as a grease and rubber adhesive solvent. It is also used as a fixative for photocopier toner.

Lime (CaO) (Calcium oxide, quicklime): Used with caustic soda to break down cotton and linen rags for paper making.

Lime, bisulphate of: *See* gypsum.

Lime, chloride of ($CaCl_2$) (**Calcium chloride**): Used to bleach paper pulp.

Limited edition: A printing run of pre-determined length which is not exceeded or reprinted. Each print in a limited edition is signed and numbered by the artist to guarantee quality and that the edition is limited to the declared number. *See also* cancellation.

Limp binding: A soft cover on a book which often extends beyond the page edges to fold in and protect them.

Lineart: Computer term for black line images such as text, drawings and designs.

Lineblock: Photo-etched relief block for letterpress printing consisting of lines and solid areas only, no halftones. Also called line-cut,-engraving,-etching, or-plate.

Linen: *See* flax.

Lining: Sheets of strong paper pasted to the inside of boards to equal the warping created by the material pasted on the front of the boards. Also the mull and strong paper pasted onto the back of sewn sections of a book.

Linocut: Engraving on linoleum.

Linoleum: A flooring material developed in the 19th century made of hydrogenated linseed oil with various other ingredients rolled on a base of hessian or woven jute fibre. The thicker, plain types of linoleum (often called battleship lino because it was made for the floors in ships) have been used for engraving by artists since the beginning of the 20th century. Now largely replaced by vinyl and other plastics.

Linolschnitt: German for a linocut.

Linotype: A machine which casts type in solid lines.

Linseed oil: Pressed from flax seed. High in fatty acids, occasionally used in the manufacture of lithographic drawing crayon and inks. Its main use in printmaking is in reducing oil-based inks.

LPI: Lines per inch. A measurement for halftone screens.

Liquid ground: A hard etching ground of resin dust suspended in alcohol which can be brushed or poured over the plate.

Liquid paraffin: Used to make paper transparent so that it can be used as a photographic positive or negative.

Lith film: A high contrast photographic film which records

only black and white, without tones. It is used for all 'line' work and also in conjunction with halftone screens.

Lith.: Greek for 'stone' or the 'lithographer'; seen on old prints.

Lithography: Derived from the Greek lithos – stone, graphos – drawing. Invented in 1798/9 by Alois Senefelder in Bavaria and based on the antipathy of grease and water. Rapidly spread all over Europe and North America for commercial printing but it was also used by artists from the beginning. Lighter weight alternatives to stone were developed, first zinc plate then aluminium. In the form of offset lithography it is the foremost system for commercial printing today. *See also* direct lithographic press and offset.

Lithopone: A white pigment (barium sulphate and zinc sulphide) used in inks and paints now largely replaced by titanium white. Also used as a filler in paper.

Lithotine: A US turpentine substitute developed by the Lithographic Technical Foundation in 1933: pine oil, castor oil and ester gum added to benzine or mineral spirits; it is less irritating to the skin than turpentine.

Lithotint: An early form of chromolithography which used washes, patented by Charles Hullmandel in the 1820s.

Litho wash drawing: Another name for lithotint.

Loaded stick: A bookbinder's tool made of a wooden stick loaded at one end with lead. It is used to beat down the sections of a book while sewing them together.

LOADED STICK

LOM: Laminated object manufacturing starts with a digital 3D image and cuts layers of sheet material which are laminated together to make a solid object; used by sculptors.

Loose gumming: Used in lithography when quick changes of colour are needed during proofing.

Loose leaf: Single sheets of paper held together by rings, spirals or combs.

Lo-Shu wash: In stone lithography where the reticulations of a wash are white or negative.

Lower case: A typographic term for the small letters in a font. Derived from the compositor's type storage case. *See also* capitals and upper case.

Luminosity: The colour remaining when all other coloured light is absorbed.

Lustre or crocus paper: Used for the fine polishing of metal plates.

Lye: Any strong alkaline solution, usually soda ash, caustic soda or caustic potash. All saponify fats into soaps making them soluble in water. Used to breakdown the image on a zinc lithographic plate prior to regraining. Also used in the photopolymer film (Riston, Imagon and Photec) process.

Lye wipe: Used with intaglio plates inked with oil paint which helps to keep clean colours.

M

Machine made paper: *See* Fourdrinier.

Maculature: French for the second impression taken from a printing matrix without re-inking, to remove excess ink. They sometimes appear for sale as do other working proofs.

Magnesium alloy: Occasionally used for intaglio plates.

Magnesium carbonate ($MgCO_3$): A fluffy white powder added to ink to stiffen it or bulk it up. Also used to dust a wet proof during a quick proofing session to allow a new colour to be added without fully drying the proof.

Magnesium nitrate ($Mg(NO_3)_2$• $6H_2O$): Used in lithographic etch and fountain solution.

Make ready: Layers of thin paper pasted under a block or to a tympan to even out irregular pressure points in relief printing.

Ma lian: Chinese for a Japanese baren.

Mangle: Old cast iron clothes mangles are used as relief printing presses with some small modifications.

Manière cribleé: *See* dotted print.

Manière noir: Where a tonal design is created by rubbing, dissolving or scraping away a solid black field on a mezzotint or aquatint plate or a lithographic matrix. *See* mezzotint.

Maps: The computer memory records each pixel of colour.

Marble: A form of limestone which can be used for lithography.

Marbles: Glass or steel marbles are used in lithographic plate graining machines together with an abrasive powder and water. When the machine is agitated, the plate is regrained according to the grit size of the abrasive.

Marbling: Imitation marble patterning on paper developed in Persia in the 15-16th centuries. Paper is marbled by lowering the sheet onto a mixture of oil-based paint and a gel such as carageen moss held in a tray which has been manipulated to produce the characteristic patterns. In intaglio, a plate is lowered face down on a dish containing a mixture of varnish and water, when lifted and dried the varnish gives a marbled resist. In lithography a marbled effect is made with a lithographic ink and turpentine wash. The turpentine evaporates to leave a characteristic image. *See also* suminagashi.

Margin: The unprinted border around an image or the non-printing area around a stone, plate, block or screen.

Marunomi: A large, round Japanese chisel.

MARUNOMI

Mask: Digital imaging uses masked areas so that specific parts can be manipulated without affecting the whole.

Masking: The use of various materials such as liquids, crayons, wax, film, paper, rice grains, sand and others which impede the application of ink, etches or light to the printing matrix during preparation.

Masking fluid: A rubber-based liquid which can be applied by brush or pen to paper or a lithographic plate or stone, Once dry the fluid can be worked over and when the new

work is dry, the masking fluid is rubbed off leaving a negative image.

Masking tape: A low-tack adhesive paper tape widely used in printmaking to hold things in place and mark specific places.

Masonite: A trade name in US for pressed wood fibreboard. *See* hardboard.

Mass tone: The hue of a thick mass of ink.

Master printer: A skilled printmaking specialist who usually works in collaboration with the artist.

Master proof: *See bon à tirer.*

Mastic: A natural tree resin used to harden crayons. Also called colophony.

Mat: A US term for a print mount which should be made of non-acidic board and be in the form of a backing sheet to which the print is hinged and a front mount with a window cut out which gives the print protection from abrasion.

Mat burn: Discolouration of the margins of a print due to the chemical content of an unsuitable acidic mounting board.

Matrix: The printing surface which

may be stone, metal, wood, linoleum, rubber, plastic, card, paper, glass or stretched textile screen. It is also the mould from which metal type is cast.

Matt: UK spelling of mat, also a dull finish.

Mattoir: A metal punch with rows of raised dots used in stipple engraving like the roulette. Also called a mace head and *opus mallei*.

MATTOIR

Mauling: The grinding of powder pigments; the same as mulling.

Measure: The width of a column of type measured in ems, picas or millimetres. *See also* em.

Mechanical screen: *See* halftone and screen, halftone.

Medium: A paper size 458 x 635mm (18 x 25in.). In printmaking it

indicates the specific technique used: relief, intaglio, lithography, screenprinting or digital printmaking. Also the substance which binds pigment in ink or paint.

Medium density fibreboard (MDF): A board made for the furniture trade but also used for cutting relief blocks.

Megabyte: MB is the computer term for 1024 bytes. The size of an image file may be given in MB to indicate the amount of space it will take up in the computer memory RAM or on disk.

Meisenbach process: An early form of relief halftone.

Mercury vapour lamp: An ultraviolet light source.

Merged colours: *See* blended colours.

Mesh: A general term for the woven textile stretched over a frame in screenprinting. Today monofilament polyester is the common choice.

Mesh count: The number and diameter of threads per cm. The thread diameter is expressed as standard (t) or heavy duty (hd) or, more recently, in microns.

Metal cut: Early engraved metal plates relief printed.

Metallic powders: Made from bronze or aluminium giving a wide range of metallic effects: silver, gold, brass, bronze and copper. Dusted over a pre-printed wet ink or varnish base of appropriate colour; the excess powder is brushed off when the ink has dried.

Methanol (CH_3OH) (Methyl hydrate or methyl alcohol): A colourless liquid used as a thinning agent in shellac coatings on lithographic plates.

Methyl salicylate (Oil of wintergreen): Used as a solvent when transferring photocopies. Once considered safer than most solvents, now in doubt.

Methylated spirits: A mixture of ethanol and methanol with added blue dye to make it unpalatable (called denatured alcohol in US). Used as a shellac solvent and general grease solvent.

Metzograph: *See* screen, halftone.

Mexphalte: A type of bitumen used in etching grounds.

Mezzotint: *manière noire* (French), *schwabmanier* (German), *mezzotinto* (Italian). An engraving technique, invented in 1642, where the metal plate is indented by rocking a toothed metal tool all over. Each pit

can carry ink and if inked at this stage the print would be solid black. The indentations are gradually burnished to reduce the ink-holding pits so an infinite number of tones can be created from solid black to pure white (where the plate is smooth and can not hold any ink). *See also* rocked plate and rocker.

Microtint: A patented surface texture made in the Electroetch process.

Mild steel: Sheet steel used for etching, the mordant is nitric or hydrochloric acid.

Millboard: A hard rolled cardboard used in bookbinding.

Mineral oil: Sold as baby oil, it is useful for softening any ingrained ink on hands; use before washing.

Mineral spirits: The US term for white spirit. A mixture of liquid aliphatic hydrocarbons distilled from petroleum used as a grease solvent.

Mineral turps: Another name for kerosene or paraffin.

Mitsumata: A Japanese plant (*edgeworthia chrysantha*) fibre used to make paper. *See also Kyokashi*.

Mixed media print: A print in which

several different printing methods are used, e.g. screenprint and etching, woodcut and lithography or digital inkjet with screenprinting and relief.

Modifiers: Additives to ink which change its stickiness or viscosity such as varnish or magnesium carbonate.

Modem: A device, separate or built into a computer which uses a telephone line to connect to the Internet and World Wide Web. Printmakers use it to contact colleagues, galleries, printers and suppliers and to display their own prints.

Moiré patterns: Screen interference patterns form if the angle of a cross-line screen is not rotated for each halftone colour. It also occurs when a halftone dot pattern clashes with the weave of a screen mesh.

Monitor: Computer screen. Artists should be able to display the full range of colours, flicker free.

Monochrome: A single coloured print, sometimes, but not always, black.

Monofilament: Synthetic screen meshes are usually woven from single threads of a standard constant diameter which are welded at the fibre crosses. These are the most

widely used meshes as they are fine and easier to clean than others.

Monoprint: An impression from a printing matrix which is uniquely different from other prints taken from the same matrix in terms of colour, paper or finish.

Monotype: A single impression, not repeatable. A unique print where the image must be re-created each time, there is no re-usable printing matrix. It was also the trade name of a famous typefounding company.

Monotype machine: Invented in 1894 to cast individual metal type characters in justified lines.

Mordant: Acid used for etching.

Morsure: French for the process of biting in acid.

Mould: The rectangular frame covered with metal gauze, or fine bamboo strips in Asia, which is dipped into a vat of paper pulp, shaken and drained, then handed to the coucher in the making of handmade paper. *See also* vatman and layman.

Mouldmade paper: *See* cylinder mould paper making machine.

Mould side: The bottom side of a mouldmade paper sheet which shows a slight mesh pattern; the watermark will be read in reverse from this side.

Mount: *See* mat.

Mounted block: Thin relief or collagraph printing plates or blocks are often glued or pinned to another backing board for strength, ease of handling or to bring the surface up to type-height.

Mouse: Computer pointing device.

MSDS: Material safety data sheets list technical information from manufacturers.

Mull: A dressed gauze used in bookbinding; also known as scrim.

Muller: A round piece of glass or marble, flat on the bottom and with a knob on top for the hand. It is used to crush and grind small quantities of pigments with a little oil or water. Larger quantities are ground in a triple roll mill.

MULLERS

Multi-block printing: Where separate blocks or plates of variable size are used for each colour but assembled and printed together. They may fit together (*see* jigsaw) or be of freeform shapes which are registered on a backing sheet or base.

Multi-coloured inking: Where several colours are applied to one block or plate. The different areas are usually separate from each other and ink can be applied by small roller, brush or dabber (*poupée*). Stencils can also be used to to apply spot colours.

Multifilament: Screen meshes, usually of an organic origin, are woven from threads made up from several strands twisted together. They are used for coarser work as they are less fine than monofilaments; they are also less easy to clean.

Multiple: A mass-produced artwork very popular in the late 1960s.

Multiple editions: More than one edition of the same print. Often printed on a different paper and in different edition sizes, i.e. a first small edition on a rare paper, a second larger edition on a mouldmade paper and finally a mass edition on machine-made paper and often signed on the plate (a printed signature). More common in Europe than elsewhere.

Multiple plate printing: Similar to multi-block printing but the blocks or plates are all of the same size.

Multiple tool: An engraving tool which cuts several parallel lines together. Tools are available with two to seven cutting edges made for wood or metal engraving.

MULTIPLE TOOL

Muriatic acid: *See* hydrochloric acid.

Museum board: *See* archival papers and boards.

Mylar: Trade name for polyethelene terephthlate. Transparent sheet which is dimensionally stable and can be grained on one side. It is used to check registration and as a drawing substrate.

N

Nacré: A pearlescent shine. Mica powder can be added to ink or dusted on tacky ink or varnish. Japanese *Inomachi* paper has a nacreous finish.

Nap roller: A lithographic ink roller covered in suede leather.

Nature print: This process was patented in 1852. Thin, flat objects (leaves, lace etc.) were placed between a sheet of soft lead and one of steel, after passing through an intaglio press the perfect impression in the lead was double electrotyped and printed intaglio, relief or transferred to lithographic stone.

Needle: A steel tool with a needle point used in etching to draw the design through the ground thus exposing the metal beneath ready for etching by acid. Hence needling.

Negative: The result of exposing glass or film coated with a light-sensitive emulsion. The silver salts in the emulsion darken in proportion

NEEDLES

to the intensity of the light. A positive can be made from the negative. The term also refers to indirect working i.e. lift techniques in intaglio and to a design with white lines on a black background.

Nelson print: Topographical prints of the 1850s and 1860s were printed from one lithographic stone in purple plus two wood engravings in pale blue and pale brown.

Newsprint: Cheap all-purpose wood pulp paper used widely in the workshop for initial proofing, blotting and mopping up ink.

DICTIONARY OF PRINTMAKING TERMS

Newton: The international standard measurement of force used by screenprinters to test mesh tension.

NIP: Non-impact print is term used for prints produced without pressure during printing including inkjet, thermal imaging, photochemical and electrophotography, toner and laser printing.

Nipping press: A heavy wood or cast iron screw press used for bookbinding.

Nitric acid (HNO_3): Used to etch copper, zinc and steel diluted with water. Also added to lithographic etch.

Nitrile gloves: Rubber gloves which do not react with oils and chemicals and should be worn when cleaning up ink.

Noir à monter: A soft, greasy lithographic ink made by Charbonnel.

Non-drying black: A lithographic ink containing lard or a similar substance.

Nori: Japanese rice paste used with water-based colours for printing. It gives a uniform body, a matt result and retards drying. Many artists prefer to use wheat paste today.

Numbering: All prints in an edition are numbered in pencil to indicate the total published (the lower or larger figure) and the individual print number (upper or smaller figure) i.e. $^{23}/_{50}$.

Number of blocks etc: The number of printing matrices may not be an accurate record of the number of colours printed especially when multi-coloured inking is used.

Number of colours: *See* above and multi-coloured inking.

Nylon: Brushes made of nylon can be used with acid and alkali etches.

O

Objet trouvé: French for a found object which, if flattish, can be inked and printed. May be natural: leaves, thin pieces of wood or fabricated: textile, metal, plastics. Either printed relief, impressed into a soft ground for intaglio or transferred manually or photographically for lithography, screen or digital work.

Octavo: A book size where the paper has been folded eight times to make the page size i.e. crown octavo: 190 x 127mm (7.5 x 5in.). Also expressed as 8to.

Offset: An inked matrix is first printed onto a rubber blanket (cylinder) and transferred on to the printing paper. Also a relief proof can be taken and offset onto a new block as a guide to cutting another colour in registration. *See also* lithography and letterset.

OHSA: Occupational Safety and Health Administration in Canada and US.

Oil pastel and crayon: Used to make negative drawn stencils and as a resist to water-based substances.

Oil pigment print: A form of photograph using the principle of the carbon print and hand colouring.

Oleic acid: High in fatty acids, occasionally used in lithographic drawing inks and crayons.

Oleograph: Early colour lithograph simulating oil painting. The printed image was coated with varnish and embossed with a canvas or paint texture.

Oleo-manganate of lime: A soap-like substance produced during the etching of lithographic stone in the image areas making them ink attractive or oleophilic.

Oleophilic: Grease attractive.

Onion skin paper: A thin, transparent paper used to make lithographic transfer paper for colour separations.

Onyx: Can be used as an alternative to limestone in lithography.

Open bite: In etching where a wide,

shallow area is bitten; printing ink clings to the sides of the bitten image but the bottom is wiped almost clean of ink.

Operating system: (OS). Computer programme for automatic controls in the main programme.

Optical brightening agent: Fluorescent bleach is added to some paper pulps to give the impression of whiteness in the finished papers. It soon discolours the sheet and is not recommended in artists' or archival papers. It is used in the new specially made inkjet papers.

Opus mallei: Stipple engravings made with a mattoir or mace head.

Original print: A print designed and printed by the artist or under the artist's supervision. Not a reproduction. Many attempts have been made to formulate a tighter definition but as technology is always changing the only workable definition is that an original print is one that the artist intended to be realised by creative printed means. *See also* BSI.

Orthochromatic: Photographic film which gives correct relative intensity to colours, mainly used for monochrome line negatives. *See also* panchromatic.

Outline type: A style of type design where only the outline of each letter is shown. In classical, serifed faces only the thick strokes are outlined.

Output devices: Computer monitor or printer.

Outsides: Handmade paper with major blemishes is sold 20% cheaper.

Over-etching: Where a lithographic stone or plate has been given too much or too strong an etch. In intaglio where a plate has started to break down after too long in the acid bath.

Over-inking: Where too much ink or ink of the wrong viscosity has resulted in the filling in of the image or a printed squash effect.

Over-printing: Where one colour is printed over another; transparent colours will make a third colour, opaque colours will cover those beneath.

Oxidisation: Zinc, copper, steel and aluminium plates will corrode or oxidise if unprotected.

P

Packing: Several sheets of paper placed on top of the printing paper in a relief press helps to soften and distribute the pressure. Also used under a block when burnishing or using foot pressure. Soft packing of felt or foam sheet is used with delicate blocks or where a degree of embossing is required.

Packing tape: Plastic sticky tape made for packaging is used by printmakers to seal the back of intaglio plates instead of varnish. It is used to make plate hangers to aid lifting plates out of an acid bath. It can also be used to seal screens, make simple stencils and make a texture on collage blocks.

Pad printing: A form of flexography developed for printing on glass and ceramics based on photopolymer plates. It is now widely used by artists and generally known as photopolymer relief or intaglio. *See also* photopolymer.

Page: One side of a leaf in a book.

Pagination: The numbering of pages in a book. *See also* folio.

Panchromatic: Photographic film sensitive to the whole colour spectrum. *See also* orthochromatic.

Paneoiconograph: Another name for the Gillot process.

Pantone colour system: Printed colour samples are each given a code which enables them to be matched as mixed ink or colours in another form.

Paper: A matted sheet of plant or synthetic fibres made by hand or machine.

Paper grips: A small, folded piece of paper is used between the forefinger and thumb to pick up clean paper especially during printing. Also called fingers.

PAPER GRIPS

Paper clay: A mixture of 33% paper pulp and 67% porcelain clay slip which can be printed, moulded and fired.

Paper plates: Short-run lithographic plates originally made for office copying but sometimes used by artists as a cheap alternative to zinc or aluminium plates. Those sold as 'litho sketch paper plates' can be printed on an intaglio press.

Paper surface: Papers made for artists are supplied in three usual surfaces: HP (hot pressed, glazed or very smooth); NOT (not hot but cold pressed and with a natural surface left by the couching felt); ROUGH (textured and coarse obtained by used a rough couching felt).

Paper weights: The old system measured the weight of paper by the ream (approximately 500 sheets) regardless of the size of the sheet. Today the measurement is metric and expressed as grams per square metre: gsm or gm^2.

Papier vélin: French for wove paper.

Papier vergé: French for laid paper.

Papurograph: A 19th century name for transfer lithography.

Papyrus: A proto-paper made from an Egyptian reed which is flattened, cut into strips and laid at right angles in layers with glue. It is then beaten to amalgamate the fibres. Still made today.

Paraffin: Called kerosene in US. It is a grease solvent and used in some lithographic crayons.

Parchment: Goat or sheep skin which is split and using only the inner layer, it is scraped and preserved. Traditionally used for manuscripts but it can be dampened and printed relief or intaglio. Parchment paper is an imitation.

Pass: The period during the graining of lithographic stone when the grit and water turns to an immovable slurry. It is washed off and the next pass started. The term is also used to describe the path of an inked roller on a printing matrix during the charging of ink; also called a set of rolls.

Paste print: A rare 15th century technique where a relief block is impressed into paste on paper.

Paste/PVA mixture: Used in bookbinding, it is stronger than paste alone and dries more slowly than PVA alone thus allowing re-positioning.

PC: Personal computers. *See also* RAM.

PDL: Computer term for page description language which is an object-based system for describing text and images on a page i.e. Adobe PostScript, Hewlett-Packard PCL.

Peau de crapaud: The French for 'skin of a toad'; used to describe a texture of fine reticulated lithographic washes.

Peripherals: The input and output devices plugged into a computer i.e. scanner, printer etc.

Perspex: UK trade name for an acrylic plastic sheet. *See also* Plexiglas.

Pewter print-type: Another name for relief etching.

pH indicator papers: Used to check the acidity or alkalinity of solutions such as lithographic gum etch.

pH scale: A logarithmic scale for expressing acidity and alkalinity. Neutral is pH7, below that is acidic, above is alkaline.

Phenol (C_6H_5OH) (Carbolic acid): A fungicide added to paper dampening water to impeded the growth of mould on paper.

Phenolic sheet: A plastic sheet used for tympans.

Phosphoric acid (H_3PO_4): Used as a delicate lithographic stone etch. Also used in anti-tinting (fountain) solution for lithographic zinc and aluminium plates.

Photo CD: A CD-ROM containing digital image files derived from conventional photographs.

Photochrom: A late 19th century process for screenless continuous tone lithography. *See also* Derby print process.

Photochromolithograph: A term for colour photolithography at the end of the 19th century.

Photochromotype -typograph: A term for colour relief halftone at the end of the 19th century.

Photocollograph: An early name for collotype.

Photo-electric engraving: Another name for photogalvanography.

Photo-engraving: An early name for relief halftone.

Photo-etching, -lithograph, -relief, -screen: A print incorporating photographic images.

Photogalvanography: A process patented in 1854 to reproduce photographs using a reticulated

gelatine image which was double electrotyped and printed intaglio. A forerunner of collotype and photogravure.

Photo-gelatine process: Another name for collotype.

Photogenic drawing: The process discovered in 1834 by Fox Talbot when an object placed on a light-sensitive paper is recorded in negative. *See also* photogram.

Photoglyphic engraving: Early experiments to make photographic printing plates were begun by J.N. Niepce in 1827, L.M. Daguerre in 1839 and H. Fox Talbot in 1852 who patented his process as photoglyphic engraving.

Photoglyptic: The French name for Woodburytype.

Photoglym -glyph: An early name for photogravure.

Photogram: Objects are placed directly on photographic paper and exposed to light. Very popular in 1920s and 1930s. Also known as a shadowgram.

Photogravure: Invented in 1879 by Karl Klic. A copper plate was covered by a dusting of resin powder, heated and fused to the metal. A sheet of bichromated gelatine tissue (*see*

carbon tissue) was laid on top and exposed with a positive transparency. Light hardened the gelatine variably giving a continuous tone acid resist which could be etched. This was later modified using a cross-ruled halftone screen and cylinder mounted plates. It became the fastest printing method for mass circulation magazines until web offset replaced it. Today the term is, confusingly, used by artists to mean halftone photo-etching using a cross-ruled screen or stochastic screen or using aquatint or carbon tissue or flexography or photopolymer.

Photo-intaglio: Another name for photogravure.

Photolithography: Invented in France in 1853 using a coating of bitumen dissolved in ether on the stone. After exposure with a negative the unhardened bitumen was washed away and the remaining image accepted ink.

Photomechanical: A broad term for any reproductive process which uses photography to create the printing matrix.

Photo-mezzotint: Another name for sand grain photogravure.

Photopaque: An opaque reddish liquid used to spot (paint out) holes in a negative.

Photopolymers: A group of plastics which are light sensitive. Used in printmaking in the form of films and emulsions which are applied to a backing of metal, plastic, board, screen or as pre-coated intaglio or relief plates (flexography).

Photo-relief engraving: Another name for lineblock.

Photosensitive: A film or liquid which reacts to light and produces a chemical change i.e. exposed areas are hardened in photographic film.

Photostat: Photosensitive paper used to make direct facsimile copies without a negative.

Photostencil: *See* stencil.

Photo-tint: Another name for ink photo.

Phototype: The name given to early experiments in photolithography by F. Joubert in France in 1860. Also the name given in 1868 by Fruwirth and Hawkins for a photographically produced relief block, a precurser of the lineblock.

Phototypie: French term for collotype.

Photo-xylograph: Woodcut or wood engraving where the block was coated with a light sensitive emulsion, exposed to a negative, developed and used as a guide to hand cutting.

Photo-zincograph: Photolithography on zinc plate; developed by 1859 for map printing.

Photo-zincotype: Another name for a process lineblock.

Phytochromography: Printing with inks derived from plant sources.

Pica: UK and USA typographic unit of measurement of 12 points (6 picas = one inch). Synonymous with the em but the pica was more generally used in the US for metal type, now it is ubiquitous in computer typesetting. *See also* em and point.

Picking: During printing specks of paper fibre become loose and leave an unprinted patch usually due to the ink being too dry or the paper being dusty or with loosely attached surface particles.

Pictograph: A pictorial symbol.

Pictography: A small format computer printer which gives photographic quality using laser diodes to create a dye image on a intermediary surface which is then transferred to the final paper.

Piezo inkjet: A piezo electric crystal in an inkjet printer gives fine control on dot size and shape.

Pigment: The solid coloured particles in inks, paints and dyes.

Pigment-based inks: Inkjet inks are still generally dye-based but new pigment-based inks are claimed to have 200 years of light fastness in standard conditions.

Pigment paper: *See* carbon tissue.

Pin bar system: A registration system used when making multiple exposures of screen stencils and lithographic images.

Pins for registration: Fine metal points put through the printing paper from the reverse to engage in a hole in the printing matrix. Also fixed pins or studs on the press on which the printing paper engages matching holes.

Pinxit: Latin for 'painted it'; seen on old prints which are copies of a painting, it comes after the originating artist's name.

Pirated copy: Enfringement of copyright.

Pixel: The tiny dots which make up the image on a computer screen.

Pixelated: An image showing the structure of the pixels.

Pixel-mapped image: The image is represented in the computer as a grid of pixel values.

Plank: Cut of wood parallel to the grain, used for woodcuts.

PLANK

Planographic: Printing from a flat surface such as in lithography and some forms of monotype. The term has been used to include screenprinting but that is now considered a separate print medium.

Plaster print: A print taken from an engraved plaster of Paris (a form of gypsum) block, previously sealed and hardened by shellac; it is printed by burnishing. Plaster can also be poured onto an inked intaglio plate, fitted with a temporary retaining wall, which gives an inked impression on plaster.

Plastic rollers: Made of polyvinyl chloride or polyurathane; they are stable and durable, available in various degrees of hardness or shore. *See also* durometer.

Plasticene: A mixture of clay and oil which can be used to make a relief block by rolling out level, cutting and inscribing. Printing by hand burnishing.

Plastic wood: A filler used to make good mistaken cut marks in woodblocks.

Plate: A sheet of metal, card, board or plastic which can be engraved, etched or collaged and printed; thinner than a block.

Plate mark: The indented edge of a block or plate in the `paper. A characteristic of all intaglio prints. A false plate mark is the blind embossing of a rectangle to create an imitation mark. It was used to deceive but is now being revived as an artistic device on relief prints, lithographs, screenprints and digital prints.

Plate tone: The small blemishes which can show in early impressions of an intaglio plate. *See also* surface tone.

Platinum print: A photograph using platinum salts instead of silver. Very popular in the 1880s and 1890s. The Platinotype Company made the photographic paper from 1870, hence the platinotype print. Again revived by photographers today.

Plexiglas: A US trade name (Perspex in Britain) for an unbreakable, transparent acrylic sheet. An ultra violet filtering variety is recommended for framing. It is also used for large drypoint plates.

Plotter: A flatbed or drum device controlled by a computer with pens attached to a moving head which produces line drawings up to A0 size. An etching needle can replace the pen to move over a grounded plate.

Plywood: A sheet made from thin slices of wood laid alternately cross grain and glued. It is available in very large sizes and the fine quality and veneer ply is used for relief blocks.

PLYWOOD

Pochoir: French for a hand-printed stencil image or print. Watercolour or gouache is applied by brush or sponge through a stencil cut from strong, oiled paper, acrylic sheet or thin metal sheet. In the 19th and early 20th centuries colours were added to pre-printed lithographic or collotype designs; it is still occasionally used for some short-run facsimile reproductions: *Jazz* by Matisse was printed by artisans using *pochoir*. Today artists print their own *pochoirs*.

Point: A UK and US typographic unit of measurement: one point = $1/72$ of an inch, 12 points = one em/pica.

Polyautography: An early name for lithography in Britain.

Polyester lithographic plates: Thin plastic sheets which can be printed in a photocopier or laser inkjet printer or drawn in toner and heated and then used as lithographic plates without any further processing. They are dampened and rolled up in the usual way but can be printed in a lithographic press or an intaglio press.

Polymer clay: A mixture of clay and a polymer binder which is used to make relief blocks. The clay is rolled out level, cut, inscribed and impressed and then dried slowly by air or fast in an oven; it can then be printed on a relief press.

Posterisation: A colour image is scanned into the four standard colours, CMYK, each in three tones, light, medium and dark (under exposed, normal and over exposed). When printed in 12 colours (which may be modified from the four process colours) the effect is to look much richer than usual four-colour reproduction. The same system is used with a monochrome negative in screenprinting which then gives a stronger effect when printed.

Potassium bichromate ($K_2Cr_2O_7$): In 1839 Mungo Ponton discovered that it was light-sensitive and H. Fox Talbot used it in 1852 to harden gelatine and make the first photographic printing plates. Now it is superseded by photopolymers and other manufactured compounds but is still used by artists in the traditional way by mixing with gelatine and coating plates and screens to make a light-sensitive surface.

Potassium hydroxide (KOH): *See also* lye.

Potassium sulphate (K_2SO_4): *See also* salt, used as an alternative.

Pottery tissue: A thin paper used to print transfers for ceramics.

Poupée: See a la poupée.

PPI: Pixels per inch is a measurement of the spatial resolution or level of detail in a pixel-mapped image.

Prelims: Preliminary matter. The first few pages of a book before the text including the half title, title page, imprint, contents, list of illustrations, foreword, preface and introduction.

Prepasol: A UK trade name for a popular lithographic plate preparation solution containing hydrochloric acid.

Press: A mechanical device to exert pressure on a printing matrix and paper. Hand operated or motorised, direct or indirect (offset), flat bed, rotary, cylinder, platen or hydraulic and screenprinting apparatus.

Press black: *See* non-drying black.

Pressing boards: A bookbinder's term for wooden- or plastic-faced boards used to press paper in a stand press.

Press packing: Layers of paper, card or board used above or below the cushion of printing matrix and paper to even out pressure, to make a hard, sharp impression or alternatively a softer image. *See also* packing.

Pressure: The force used to transfer the ink from matrix to paper by hand burnishing or mechanically in a press. Pressure is adjusted by press packing or by the screws integral to some presses.

Pressure gap: The space in a picture frame between glazing and print.

Pressure washer: A high pressure water hose used to spray water on a screen during cleaning.

Print: The image on paper or other substrate usually called by the medium used i.e. an etching, a screenprint, an aquatint, a wood engraving, a woodcut etc.

Print book: Records of each edition should be kept; particularly important if only part of an edition is first printed. Also important if experimental proofing is done. Art historians love them. The following should be recorded: print method, number of colours, number of stones, blocks, plates or screens used, order of printing, paper, size, amount of dampening or other preparation, ink and any modification (with dabbed-out ink swatches), edition size, date of printing, printer(s), method of publishing (self-publishing, co-publishing or other with a copy of any contract) and details of storage. If the prints are exhibited or sold

individually each numbered print must have its own record so that it can be traced. Particularly important when prints are placed on consignment or sale-and-return.

Print cabinet: A print collection in a museum; *Cabinet des estampes* (French), *Drucke kabinett* (German). *See also calcographia.*

Print file: Computer term for the image file used for proofing and editioning.

Printed enamels: Decals printed with enamel colours are transferred to metal sheet and fired. Enamels can also be screenprinted directly on to metal.

Printer: The person operating a press or who is taking the print impression, who may be the artist, a collaborator or a technician. Also a computer attachment which prints out information stored electronically.

Printer's proof: One of the extra copies printed after the edition is complete and kept for the printer's archive.

Printer's stamp: *See* chop mark.

Printing: The method by which an image is transferred from a matrix to paper or another substrate.

Printing base: The chemical nature of an image in lithography. The term can also refer to a transparent or white base which is printed first, to seal the substrate or make it more light reflective; colours are printed on top.

Printing down frame: *See* exposure unit.

Printing order: The order of printing a series of colours must take into account the effect they will have on each other; opaque or transparent, dark or light.

Print-on-demand: The printing of individual copies as required. Now common in digital printmaking.

Prismatic colours: The seven rainbow colours.

Private press: Eric Gill defined it (1933) as 'one that prints solely what it chooses to print'.

Process camera: Professional darkroom camera used in photo-printmaking.

Process engraving: Photo-mechanical halftone blocks in monochrome, three- or four-colour systems for letterpress printing.

Processor: Computer microchip. Artists look for a high speed processor measured in MHz (megaHertz).

Program: Computer software or sets of instructions.

Progressive proofs: Colour proofs which are taken to check registration, colour over-printing and the order of colour printing. The sequence of proofs shows each colour separately and colour one plus two, one, two plus three and so on.

Proof: A trial print. *See also* proofing, *bon à tirer* and edition.

Proof reading: The checking of typesetting against the authors' manuscript and indication of corrections.

Proofing: The trial printing of each colour or element making up a completed image is used to check registration, colour values, overprinting, printing order, position on paper, types of paper and their suitability, ink mixtures and press adjustments. The object of proofing is to ensure trouble-free editioning.

Proofing paper: Newsprint is often used to pull the first few impressions while adjustments are made and the stone, block, plate or screen is being charged with ink. Then proofs are taken on the editioning paper, or various papers which might be used.

Protean print: A mid-19th century popular print which changes when held up to the light. Parts are waxed to make the paper transparent and another image is printed on the reverse or a second print is mounted behind. Also called a transparent print.

Provenance: The history of ownership of a work of art.

PSD: Photoshop file format.

Pthalocyanine pigments: A group of chemically-derived pigments also called thalo colours.

Publisher: The person who issues and sells prints and artists' books.

Publisher's proof: The copy of a print or book for the records of the publisher.

Pull: An impression taken at any stage of the printing process before the editioning.

Pulp: The mixture of water and plant fibres from which paper is made.

Pumice: An abrasive in powder, stick or block form.

Punches: Shaped steel tools that are

DICTIONARY OF PRINTMAKING TERMS

hammered into a block, plate or bookbinding, making repeated marks often in the form of dots, stars, lines and circles. *See also* dotted print.

Push: A lithographic term to describe a texture in the printed ink film caused by the paper slipping over the stone or plate or by over-inking, too much pressure or a soft ink.

Push knife: A wedge-shaped blade which is used to mix ink.

Pusher felt: *See* felt

PVA: Polyvinyl acetate emulsion is

PUSH KNIFE

used as a glue and to seal surfaces of collagraph blocks.

Pyroxylography: Woodcutting using a heated pyro pen tool. Also called pyrography.

Q

Quadrats or quads: A typographic term for metal spaces measured in units of ems, used to fill the voids and short lines in a page of type so that it can be locked solid for printing.

Quad crown: Paper size four times larger than crown: 761 x 1015mm (30 x 40in.).

Quarto: A book size where the paper is folded in four i.e. crown quarto: 254 x 190mm (10 x 7.5in.). Also expressed as 4to.

Quartz halide: An ultra violet light source.

QUOIN

Quire: Traditionally 24 sheets of paper, now accepted as 25 sheets.

Quoin: Wedge or mechanically expanding block used to lock up type in a forme so it is solid for printing.

R

Radierung: German for etching.

Rag wipe: The first cleaning of ink on an intaglio plate with scrim or tarlatan.

Rags: Absorbent, lint-free cotton rags are widely used to clean up printing equipment at the end of a session. Workshops collect old domestic rags or subscribe to a rag cleaning service. Linen rags were once the main raw material for the manufacture of paper.

Rainbow colours: *See* blended colours.

Raisin: French paper size approximately 500 x 650mm ($19^3/_4$ x $25^1/_2$ in.).

RAM: Random access memory in a computer. Artists need at least 128MG (megabytes) of RAM available.

Rasp: Used to bevel the edges of stones so the paper is not cut during printing.

Raster engraving: Digital engraving in dots or pixels. A laser head scans an original or acts on digital information and engraves one dot at a time.

Rasterisation: The conversion of a vector image into a pixel-mapped image.

Razor blade: The single edged blade can be used to scrape the surface of a new lino block to remove any manufacturer's varnish; in stone lithography it is used to erase work.

Razor hone: A type of Belgian slate used as a hone.

Ream: 480 sheets of paper (20 quires). In practice paper manufacturers vary the quantity 480 – 516 sheets.

Recto: Right hand page in a book.

Recycled paper: Old paper re-used to make new; was first manufactured by Mathias Koops in 1800.

Red oxide: Used in powder form, dusted on a sheet of paper as a non-greasy transfer paper or in pencil

form (conté), to draw directly on lithgraphic stone or plate.

Reducing medium: A transparent additive for printing ink to dilute the colour, also called extending or tinting medium.

Reducing oil: A petroleum-based solvent with a low fatty acid content; added to ink to thin it and to make it more transparent.

Reduction gear box: This is fitted to a press to motorise it.

Reduction print: A print made using only one printing matrix for a multi-coloured image. Can be a relief, screen or lithographic print. The entire edition is printed in the first colour and the matrix cleaned. Parts of the image are removed and the second colour printed and so on until all colours are printed. Also called elimination or suicide prints.

Reflective original: A photograph, painting, drawing or printed work which is on a solid substrate which reflects light.

Register marks: *See* lay marks.

Registration: The correct positioning of one colour with another during printing. Depending on the method of printing, many register plans or devices can be used: by eye, by lay marks, *Kento*, pins, needles, T-bar, notches, studs, paper clamping or nipping under the cylinder in an intaglio press.

Relief etching: A surface-printed intaglio plate.

Relief printing: Printing from the surface only of a block, stone or plate i.e. woodcut or letterpress.

Reproduction: The duplication of an original painting or drawing by photo-mechanical processes or by a copyist (*chromiste*), not an artist's original print.

Reprographics: A general term covering printing, copying and the preparatory work for printing.

Repoussage: French for hammering on the back of a metal plate in a defective area in order to raise the surface to make corrections.

Resampling: Reducing the number of pixels in an image, with corresponding loss of information. Also called down sampling.

Resin: A natural tree resin insoluble in water. *See also* shellac and aquatint.

Resin box: A perforated container like a flour sifter used to dust a fine

coat of resin powder during lithography or aquatint. *See also* dust box.

Resingrave: The trade name for epoxy resin-layed fibreboard which is used as an alternative to wood for engraving.

Resist printing: A textile technique which can be used on paper. An image printed in an ink or dye resist is over-printed with a non-resist colour, when dry the resist can be washed out.

Resists: Any materials which 'stop out' or mask areas of a printing matrix from the action of acid, alkali or light. These are either greasy or waxy substances, varnish, acrylic-based liquids or light-opaque substances.

Resolution: Computer term for the scan size counted in pixels per inch (ppi) of 150 to 300 of the final print-out size.

Restrike: The reprinting of a plate, stone or block. Certain printers have and still keep a stock of popular plates which they print to order; these are usually old topographical and hunting scenes and they are not in numbered editions. They may be of historical interest but are in a different category to artists' prints which have been signed and numbered since the 1890s. Modern restrikes are often unauthorised and made after the death of the artist.

Retarder: An additive to ink to slow drying.

Reticulation: The random pattern of fine particles or crinkles left when a lithographic tusche wash dries out or when the surface of a gelatine layer dries out.

Retree: Handmade paper which has minor blemishes and is sold 10% cheaper. *See also* outsides.

Retroussage: Ink is dragged out of an intaglio plate using a soft cloth giving a richer tone in specific areas.

Reversal of the image: The printing image on the matrix must be reversed in all relief, intaglio and direct lithographic printing. The image does not have to be reversed in offset lithography and screenprinting.

RGB: Red, green and blue light on a computer screen or scanner combine to produce the full range of colours. RGB must be converted to CMYK for output.

Rheology: A term used to describe the viscosity and construction of an ink.

Rice paper: A generalised term for any Asian paper but it is not made from rice. There is a fragile culinary 'paper' made from dried rice paste which can be used for edible prints.

Rice paste: Used for paper sizing, paper gluing and as an additive to Japanese water-based printing colours. *See also nori.*

Riffler: A small filing or scraping tool used by wood engravers and cutters.

RIFFLER

Right to print: RTP, same as BAT, it is the instruction to print an edition.

RIP: Raster image processor is a device to convert a digital image to a raster of colour values for output on a large format printer.

Rivers: A typographic term for the unsightly vertical white spaces which can occur on a page of typesetting when the word spacing is irregular and wide.

Rocked plate: A metal plate prepared for mezzotint. It may be rocked by hand or mechanically. *See also* mezzotint.

Rocker: A toothed, hardened steel tool which is rocked back and forth over a metal plate to create a texture of ink-holding pits. *See also* mezzotint.

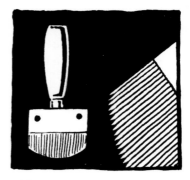

ROCKER

Roller grips: Large rollers are more easily rotated if the hands hold a loose tubular grip, usually made of leather, in which the spindles can turn.

Rollers: Used to distribute printing ink onto the matrix. They are made of a variety of substances: glue-glycerine composite, gelatine, vulcanized oil, leather, rubber and various plastics such as urethane and polyurethane. Large rollers have two spindles (handles), smaller ones have a central handle. Available in different hardnesses. *See also* durometer (US) and shore (UK).

Rolling patterns: A large image must be rolled in various directions to obtain even inking.

Roll-up ink: A lithographic ink formulated to roll-up the image after the first etch; it is stiff and of medium fatty content.

Roman: A typographic term for an upright type design. Roman numerals are expressed as capitals i.e. I, II, III, IV, V, VI etc. *See also* italic and Arabic figures.

Rosin: The solid residue after the distillation of turpentine. Used in lithography to protect the greasy image during etching.

Rotary press: The printing matrix is bent round a cylinder. This allows for fast printing on a commercial level of offset lithography, rotogravure and photogravure.

Roulette: A steel engraving tool with a small spiked wheel which makes a dotted texture directly on an intaglio plate or through a ground. It is often used where an aquatint has been rubbed down and needs some pitting added back.

Router: An electric rotary cutter used to deepen printing plates in non-printing areas.

Royal: Paper size approximately 510 x 675mm (20 x 25in.).

ROULETTE

RRED: Right reading emulsion down. Refers to the emulsion on photographic film and is important during exposure for the crisp rendering of halftones.

RREU: Right reading emulsion up. Some processes call for this arrangement. *See also* above.

Rubber cast: A liquid rubber material used to take casts from plates or blocks. When solidified it can be reworked and printed.

Rubber stamps: Small relief blocks cut into rubber (pencil rubbers can be used) or photographically produced from polymers. They can be printed on delicate surfaces such as ceramic.

Rubbing: Also called *frottage*. Used to take an impression from an incised design. It is also used to make a transfer from a natural or delicate object, such as a leaf, in lithography. It is used in Chinese water-based

printing to take 'squeeze' prints.

Rubbing up: In colour lithography, before the ink is rolled on, some dilute ink is wiped on and buffed down in place of the asphaltum which is used with black ink. The term is also used to describe the processing of acid tint images where the image is rubbed alternately with diluted ink and water.

Ruling machine: A mechanical device introduced in the late 18th century which drew regular straight or curved lines in a ground on an intaglio plate, on a lithographic stone or plate or engraved into wood or metal.

Run: In printmaking a short run would be around 25 copies or fewer and a long run anything over 60. In lithography each separate colour is considered a run even though more than one colour may be printed from one matrix if the colours are not close together.

Running head: A typographic term for a line of type at the top of each page in a book or magazine.

Rule: A strip of type high metal which prints as a line; can be straight and available in several point widths or a swelled rule in imitation of an engraved swelling line. Rules can also be decorative.

S

Safe light: The red or yellow light used in a darkroom.

Safe printmaking: Also called non-toxic printmaking. A movement started in the 1980s as a result of new health and safety legislation which aimed to replace the more noxious and carcinogenic substances used by printmakers with safer materials.

Salt (NaCl) (Sodium chloride): Household salt is used as an abrasive in reconditioning dry leather rollers. It can also be used to create a random pattern in a lithographic wash. *See also* salt aquatint.

Salt aquatint: Household salt is sprinkled on a plate with a hard ground before it is quite hard. The plate is heated to melt the ground, the salt falls through the ground to contact the metal. When cool, the plate is put in water which dissolves the salt leaving an aquatint texture.

Saltpetre (KNO$_3$) (Nitre, potassium nitrate): It is used in some lithographic crayons.

Salt wash: Finely ground household salt is added to Indian ink, 50/50 with water making a crystalline structure on polyester film when dry.

Sand: Used as an abrasive and to give texture to collagraph plates. *See also* sand grain photogravure.

Sand bag: A small round bag of leather or canvas filled with sand on which a wood engraving or metal engraving plate rests during cutting so it can be easily rotated during curved cuts.

SANDBAG

Sand grain etching: *See* sandpaper.

Sand grain mezzotint: A sheet of sandpaper is pressed into a

copperplate by running through the press, the result is not so rich as a rocked plate.

Sand grain photogravure: A photographic gelatine image was dusted with sand or emery powder. The larger grains stick to the raised, moister, darker areas with only the finest grains sticking to the lower, drier, highlight areas. An electrotype was made and printed intaglio. It was also called Goupilgraph, mezzotint photogravure or photo-mezzotint.

Sandpaper: It is used to roughen surfaces or remove unwanted material. An intact sheet can be impressed into a soft ground on a metal plate to produce a texture similar to aquatint.

Sankakuto: A Japanese v-shaped gouge.

SANKAKUTO

Sans serif: A style of type design without serifs. *See also* roman and serif.

Saponification: When oleo manganate of lime is formed during the etching of lithographic stone.

Saturation: A measure of colour depending on the degree to which it departs from white light.

Scalpel: A surgeon's knife used as a scraping tool and a knife.

SCALPELS

Scanner: A flat bed or drum computer device which converts a photograph, drawing or painting into a pixel-mapped image.

Schwabmanier: See mezzotint.

Scorper: A steel engraving tool with straight sides, square section or half round on the bottom, sharpened to an oblique face used for broad lines and gouging out areas.

SCORPOR

Scraper: A sharp triangular section steel tool with one end pointed used in intaglio and engraving. Flat scrapers with one or two sharp edges are used in mezzotint. *See also* scraping.

SCRAPER

Scraper bar: The horizontal part of a direct lithographic press which exerts the pressure as the stone or plate plus paper is rolled beneath.

Scraperboard: A board with a white clay coating and blackened surface. When drawn on with a needle or scraper a very fine white line results which can be converted into a film negative or positive. It was very popular during the 1930s and 1940s for illustration work.

Scraping: A technique for making corrections or reducing tone in lithography. Also used when making corrections to intaglio plates and sweeping away curls of engraved metal. *See also manière noir.*

Scratching: Similar to scraping but using a point. Also used in drypoint to draw an image.

Screen: A rectangular frame made of wood or metal over which a mesh of silk, synthetic textile or metal is stretched. This supports a stencil through which ink can not pass.

Screen, halftone: Halftone screens were introduced in the 1860s and consisted of black lines ruled on glass which were inserted in the camera between the negative and light-sensitive material. Cross lines became standard in the 1880s. Wavy lines and an aquatint texture have been used and a texture derived from reticulated gelatine was called a metzograph screen.

Screen filler: A thick liquid used to fill the holes between mesh threads on a screen in the non-printing areas of a stencil.

Screenless: *See* continuous tone.

DICTIONARY OF PRINTMAKING TERMS

Screen painting: An image can be painted with ink, paint or soluble crayon on the outside of a screen. When dry, it is printed with a base suitable to dissolve the image resulting in a monotype.

Screenprint: A stencil print made using a mesh-covered frame to support the stencil.

Screenprinting: Stencil printing either by hand or commercial screenprinting machines. *See also* silkscreen and serigraphy.

Screen projection system: Photoscreen stencils are cut by a computer controlled laser.

Screw press: A simple press consisting of a rectangular flat bed and a platen above which is raised and lowered using a screw. Made of wood or caste iron, they are principally used by bookbinders to press paper and books. Artists making paper also use them to press water out of a stack of formed sheets and felts. Printmakers also use them to print relief blocks. Also called a stand press.

Scrim: *See* tarlatan.

Script: A typeface design in imitation of pen writing.

SCSI: Small computer systems interface is a standard system for connecting computer devices, now superseded by USB.

Sculpsit: Latin for 'engraved it' on old prints, it denotes the engraver.

Scumble: *See* dry brush.

Scumming: Where a lithographic stone or plate does not ink up cleanly and some ink is deposited in non-image areas. *See also* anti-tinting.

Sealant: Varnish or dilute PVA is used to seal the surface of linoleum, wood and collaged materials to improve the acceptance of ink and to reduce the amount used.

Second editions: When an uncancelled matrix is reprinted. Used to be common with wood engravings and some other relief prints but now generally discouraged. Such editions should always have 'second edition' written in pencil beside the edition number.

Senefelder, Alois (1771-1834): The inventor and developer of lithography in 1798. The first lithographic workshops were established in Munich and Offenbach in Bavaria in 1799. It soon spread all over Europe and North America and thence to other countries.

Sensitising: In photographic processes the light-reacting salts or other compounds which harden when exposed to light. *See also* counter-etching.

Separations: Each colour used in a print is drawn, painted or plotted on a separate sheet of paper or film; it can be done by hand, photographically or digitally.

Serif: A typographic term for type designs where the tops, bottoms and ends of strokes are finished horizontally or vertically. Serifs derived from stonecutting techniques and can be seen on all classical type. *See also* roman and sans serif.

Serigraph: The name given to artist-printed screenprints as opposed to commercial screenprinting. Still used in Europe and North America.

Serigraphy: Screenprinting derived from the early use of silk to make the screen. Now superseded by synthetic textile meshes.

Set of rolls: In lithography, the number of times the inking roller is passed over the matrix before recharging and sponging is counted to maintain the consistency during printing. Can also refer to the number of rollers on an automatic inking machine.

Set of type: The width of a type body. *See also* shank.

Set-off: A method of transferring a non-printing guide outline drawing on a lithographic stone or plate. Also if prints are piled up whilst still wet the ink will set-off on the back of the next print.

Set square: A triangle of plastic sheet with one 90° angle and two of 45° used to check accuracy of corners.

Setswell: US trade name for an ink modifier similar to Vaseline or petroleum jelly. Slows the drying time of ink.

Setting: *See* composing.

Sewing frame: A piece of bookbinder's equipment used while the sections of a book are being sewn together.

Sewing keys: A bookbinder's term for metal shapes which hold cord and tape while using a sewing frame.

SEWING KEYS

Shadow type: A design of a typeface which has shadows giving the illusion of three dimensions.

Shadowgram: *See* photogram

Shank: The body of a piece of metal type measured in points from back to front.

BOOKBINDERS SHEERS

Shears: Heavy duty scissors; bookbinders shears have one squared off blade. Also the US term for a large metal cutting guillotine.

Shellac: A natural tree resin which, when diluted in methylated spirits (denatured alcohol), is used as a waterproofing solution on wooden screen frames and blocks and plates to prevent the absorption of oil- or water-based printing ink.

Shintorinoko: *See torinoko.*

Shop black: Flat areas of colour in lithography are drawn up in a mixture of *Noir à Monter* ink and

aspheltum thinned with turpentine. It is also used to prepare for an acid tint.

Shore: *See* durometer.

Shoulder: The non-printing area surrounding the face of a piece of metal type.

Siccative: A drying agent added to inks.

Siderography: A process to duplicate hardened steel engravings particularly for security printing.

Sieve print: *See* screenprint.

Signature: The artist's name written on a print conveys approval. It is usually made in pencil because that is more difficult to erase or change without disturbing the paper fibres. The term is also used for groups of pages bound together in a book.

Signed in (on) the plate: The artist's signature is transferred or incorporated on the matrix and so is printed; each print has not been given individual approval by the artist.

Signing: *See* signature.

Silicone impregnated paper: Sold as baking parchment, it can be screenprinted and then transferred,

upside-down, by rubbing, onto many three-dimensional surfaces. Nothing sticks to it so it is useful to wrap small quantities of oil-based inks, to interleave photopolymer plates and many other studio situations. Also called silicone release paper.

Silicone intaglio: Silicone coated lithographic plates (*see* waterless lithography) are used for drypoint and engraving. Rubber based lithographic inks and new water based inks are used and they are printed in an intaglio press.

Siligraphy: The term used for waterless lithography by artists. *See also* waterless lithography.

Silk: Used as a early screen mesh but now superseded by monofiliments. Also used wrapped round a finger to apply lithographic chalk or crayon. It can be printed on by relief, intaglio, screen and lithography. *See also* serigraphy.

Silk aquatint: A form of collagraph using a textile such as silk organdie or polyester screen mesh glued to a backing board. Non-printing areas are blocked out with acrylic paint mixed with medium or gel, ink is held in the pockets between threads. The plates are printed intaglio.

Silkscreen: An alternative name for screenprinting still common

in North America.

Simulated halftones: A digital alternative to photographic halftone screens.

Simulator: *See* tracing paper.

Size: Where the size of a print is given in a catalogue it should say whether it is the image size or paper size, generally given height before width. Size is also a gelatinous solution, originally animal glue but now usually cellulose or other synthetic glues, used to glaze paper making it stronger but less receptive to water-based colours. Size can be added to the paper pulp vat or applied later.

Slate: Used as an alternative to limestone in lithography. Also used to engrave relief blocks.

Slip sheet: A sheet of acid-free paper interleaved between prints.

Slips: A bookbinder's term for the cords or tapes onto which the sections are sewn; the slips are fixed onto the boards.

Small caps: Most fonts include small capitals, which are the x-height size, as well as full-size caps. They are used where full-sized caps would look over-emphatic in a sentence of text.

Smoking plates: The ground on an intaglio plate is smoked with a bundle of tapers allowing the flame to go all over the plate evenly to darken the ground and make the work easier to *see* and to smooth the ground level.

Snake slips: Fine abrasive stones used to sharpen metal tools and to make corrections in lithography.

Snap: The distence between the underside of a printing screen and the paper. Also called lift off and off contact.

Soainomi: A Japanese clearing chisel.

SOAINOMI

Soaker: *See* felt.

Soap: A mixture of sodium salts of fatty acid radicals made by boiling natural fats and oils with strong alkalis such as sodium and potassium hydroxide; glycerine is a by-product. An emulsifying agent of oil, grease and water. Used as a general cleaning agent, and in solution, as a wetting agent to break surface tension of liquids. It is used as an ingredient in lithographic crayons and tusche.

Soap wash: A drawing technique used in lithography.

Soda ash (Na_2CO_3) (Anhydrous sodium carbonate): A strong solution is used to strip used photopolymer film from its backing. *See also* lye.

Sodium thiosulphate ($Na_2S_2O_3$): 'Hypo'. A slow acting fixing agent for photographic emulsions.

Soft ground: Grease is added to intaglio hard ground to make it soft and receptive to marks embossed on it which then exposes the metal plate to acid.

Soft soap: A liquid vegetable oil potash soap is used to size pottery tissue before printing to lubricate the transfer of the image.

Software: Computer programs, packages and applications.

SoHo: Small office/home computers.

Solander box: A storage box for works on paper. It is made of acid-

free board, one side opens so the paper or mounts can be safely slid out. It is the preferred conservation method of museums and archives.

Solarplates: The Australian name for photopolymer etching (flexographic) plates when sun is used as the light source.

Solid inkjet printer: Solid wax-based inks are melted just before transfer to the substrate.

Solnhofen stone: The best limestone for lithography being fine grained and almost free of occlusions. It is still quarried in Solnhofen in Bavaria, Germany.

Solvents: A substance which will dissolve others i.e. acetone, alcohol, benzine, cheap vegetable oil, methylated spirit or denatured alcohol, paraffin or kerosene, petrol or gasolene, turpentine, turpentine substitute, white spirit or mineral spirit, water or proprietary compounds.

Sorts: Individual pieces of metal type.

Spaces: Pieces of metal type varying in size and thickness, less than type high so they do not print, are used for letter spacing between characters or used for word spacing.

Spatter: A technique for creating a random dot pattern made by flicking a brush loaded with paint or ink.

Spatula: A long rounded-end knife used to dig ink out from tins and to mix ink.

SPATULA

Spermaceti: A crystalline wax derived from sperm whale oils similar to beeswax, was used in the making of lithographic crayons.

Spine: The back edge of the book where the pages are attached.

Spirit ground: An alternative to dusting resin for aquatint: the resin is suspended in alcohol and poured over the plate. As the alcohol evaporates it leaves the resin particles in a regular pattern. The density in the particles can be varied by tipping the plate as it dries.

Spit biting: Used to etch small areas of a plate. Spit is applied with a feather and acid dropped on; the acid will not spread, nitric acid in gum can be used the same way.

Spitsticker: An elliptical tool used in wood engraving. It is the most versatile tool and is used to engrave straight and dotted lines but is better than a graver for curved lines with less likelihood of bruising the wood.

SPITSTICKER

Split duct: *See* blended colours.

Sponge: Natural and synthetic sponges are used in lithography to apply water, etches and other liquids to the stone or plate. Also used to create texture in resists or to apply pigments or inks.

Sponge printing: Simple designs can be cut in fine textured sponge for hand printing on delicate surfaces such as ceramic.

Spoon: A domestic wooden or metal spoon used as a burnishing tool in relief printing.

Spot channels: In digital imaging a special colour area can be isolated and stored.

Spot etching: Small areas of etch are applied by an acid-resistant brush (glass fibre or nylon) in lithography and intaglio.

Spray ground: An acid resist etching ground applied by spray gun, airbrush or mouth diffuser.

Spray printing: The airbrush application of colour using stencils by hand or digitally controlled.

Squares: A bookbinder's term for the space between the edge of the leaves and the boards which overhang to protect the leaves.

Squash factor: A halo of thicker ink around a printed area indicates that the ink was too liquid or pressure was too high.

Squeegee: A rubber or urethane blade held in wooden or metal frame used to push printing ink from one end of a screen to the other in screenprinting.

Squeeze: A Chinese technique, (*ca mo ta*), also called an ink squeeze. *See also* rubbing.

Stability: Prints are subject to degradation by light, heat and other conditions such as the interaction of inks and substrates. Reputable manufacturers can advise on the stability of their products.

SQUEEGEE

Stainless steel: Sheets can be used for engraving and etching. It is also used for acid bottles.

Stamp: To impress an inked or uninked block on to a substrate. Also an embossing stamp which clamps paper between a male and female die, it is impossible to eradicate.

Stand press: *See* screw press.

Standard original: A normal image to be scanned without any particular features. *See also* heads-up original.

Stannotype: A later and cheaper version of Woodburytype.

Starch: Natural or synthetic starch is used in solution with water to size paper, glue paper and as a thickening agent in water-based inks or pigments.

Starch catcher: *See* felt.

Starch printing: A popular 19th century hobby. A leaf or other plant material is protected in some areas from light; the shaded parts make starch which can be coloured with iodine and hand printed.

State proof: A proof is taken each time work is added or subtracted from a printing matrix so that progress of the work can be checked. States are of great interest to collectors.

Stearin ($C_3H_5(C_8H_{35}O_2)_3$): A soap-like fatty acid which is added to lithographic crayons to make them insoluble in water. Stearic acid is used in lithographic ink.

Steel engraving: An engraving on steel which can be printed in very large numbers with little deterioration; characterised by a hard, precise line.

Steel-facing: The electroplating of intaglio plates to make it possible to print a long edition without wear and the breakdown of the image. Also used when red, yellow and some other inks are printed from copper which otherwise would discolour the ink.

Steel letter punches: Each letter or character in the alphabet was individually engraved in steel in relief. This was used to punch into a copper mould from which letterpress type was cast. Steel letter punches are

also used in bookbinding for titles, authors and publishers' names either blind embossed or using metallic or coloured foils.

Stencil: The mask in *pochoir* and screenprinting which prevents the ink penetrating to the substrate. The stencil can be made from cut paper, card, film or thin metal or be hand drawn or painted, photographically or digitally made.

Stenochrome: A rare 19th century colour print process.

Stenocut: Relief printing material made of a rubber composition (originally made for sandblast stencils) which is soft to cut and prints well.

Stereolithography: A laser scanner hardens photopolymer layers building up a printing surface which can be manually worked if required and then printed relief or intaglio. Also used to build up three-dimensional prototypes in industry.

Stereotype: An early name for lineblocks. *See also* electrotype.

Stipple: Stipple engraving on an intaglio plate was developed in the 1760s using the point of a graver or a mace head. The term also refers to fine dots drawn in lithography giving an impression

of tone. *See also mattoir.*

Stochastic: A mathematical formula for producing random halftone dot patterns.

Stock: Another term for the substrate, usually paper.

Stoddard solvent: *See* Varsol.

Stone: Various stones can be used for lithography but Solnhofen limestone is considered best. Stones such as slate and soapstone can be engraved. Abrasive stones are used to sharpen metal tools and to erase lithographic work. It is also the typographic term for the metal table on which type is arranged in a chase and forme for printing.

Stonecut: Soapstone engraving.

Stone engraving: A lithographic stone is covered with a water-soluble ground and the image scatched through. Ink is rubbed into the design, the ground washed out and the stone processed in the normal way.

Stop: A registration guide for positioning the paper for printing. *See also* lay marks.

Stopping out: An acid resist in liquid form used to stop areas on a plate from any further etching by the mordant.

Straight edge: A metal ruler used for measurement, for testing the level surface of a stone or woodblock and as a guide edge when tearing paper.

Straw hat varnish: Originally made to waterproof straw hats. Shellac coloured with black pigment used as stop-out in etching. It is dissolved in methylated spirits.

Stripping: Ink on a printing matrix can be removed by printing on newsprint during colour proofing rather than cleaning up each time. Excess ink on a print can also be removed with a sheet of newsprint by hand rubbing or running it through the press.

Stumping: A technique for drawing on lithographic stone developed by Charles Hullmandel in the early 1800s.

Styrene sheet: Used for lithographic monotype instead of metal plate. Also used for relief printing and cut with a router.

Subscript: Small letters or numerals which are printed below the base line of type. *See also* superscript.

Substrate: The sheet which carries the printed image; usually paper but can be card, plastic, textile, metal or wood.

Sugar etching: Sugar can be substituted for salt in aquatint. *See also* salt aquatint.

Sugar lift: A intaglio technique where a solution of sugar in water with some colouring and a touch of soap to break the surface tension is used on a brush to draw an image on a metal plate. Once dry it is covered by a liquid ground. When that is dry, the plate is washed gently in water which dissolves the sugar solution leaving a negative image in the ground. This is usually given an aquatint to hold the ink. The aquatint can also be applied before using the sugar lift solution. *See also* white ground.

Sugar paper: A cheap, coarse, tinted paper used for children's work.

Sugar syrup: Added to starch paste to make it sticky and slow to dry.

Suicide print: *See* reduction print.

Sulphite: Paper merchants' term for wood pulp.

Sulphur (S): Flowers of sulphur in machine oil painted on a copper intaglio plate will give a pale tint after about an hour. It was used in the 18th century to reproduce wash drawings but later replaced by aquatint.

Sulphuric acid (H_2SO_4) (Oil of vitriol): A corrosive liquid used in the bleaching of paper and for making corrections on aluminium lithographic plates.

Sumi: Japanese black water-based ink made from burning pine wood or rape seed oil to make soot which is then bound with glue and made into sticks. To make ink, the stick is rubbed in a little water. Reconstituted ink is also available as a liquid. *See also suzuri.*

Suminagashi: Japanese marbling technique using water-based colours on a shallow bath of plain water. *See also* marbling.

Superscript: Small letters or numerals which print above the base line of type. *See also* subscript.

Surface printing: *See* relief printing.

Surface tone: A slight film of ink left on an intaglio plate gives an overall tint or tone to the print.

Suzuri: A Japanese ink stone on which *sumi* is rubbed with a little water to make black ink.

SUZURI

Swan skin (cloth): *See* felt.

Swash letters: Some traditional italic typefaces have a set of alternative characters with extra flourishes.

Swelled rule: *See* rules.

Syrian bitumen: Better known as amber, it is sometimes added to an etching ground. *See also* ground.

T

T-bar: A registration system using a T and a bar on the printing matrix. These are lined up with similar pencil marks on the back of each sheet of paper.

Tablet and stylus: Used with a computer instead of a mouse giving finer control in interactive painting and drawing.

Tack: The stickiness of ink.

Tail: The bottom edge of a book, also called the foot.

Takuzuri: Japanese term for a rubbing.

Talc ($Mg_3Si_4O_{10}(OH)_2$) (Hydrated magnesium silicate): *See* French chalk.

Tallow: Wax from animal sources used in lithographic crayon, etching grounds and to preserve leather rollers.

Tamarind Master Printer: TMP is a professional qualification in the printing of artists' lithographs awarded by The Tamarind Institute in the USA. It was founded by June Wayne in 1960 and first funded by the Ford Foundation. It is now established in Alberquerque, New Mexico.

Tam O'Shanter snake slip stone: Used to polish the edges of lithographic stones.

Tannic acid ($C_{14}H_{10}O_9$): A mixture of acids extracted from gall nuts, similar to gallic acid. Used in lithographic gum and etch solutions.

Tarlatan: Wiping canvas or scrim. A stiff textile used in inking intaglio plates and stone engravings.

Tempera: An egg yolk and water medium for use with powder pigments.

Test paper: Paper used to test the pH of solutions, similar to litmus paper and pH paper.

Tetrapanex papiriferus: An early pre-paper was made in China from the pith of this 'rice paper' plant.

Textiles: Printing on woven materials predates printing on paper.

Textured film: Similar to drafting films but with a finer grain. They hold washes and drawings in a very fine random texture which can be used directly as negatives or positives. It is available under the trade names Lexan, Mark resist and True-grain.

Thalo: *See* pthalocyanine.

Thermal inkjet: A type of drop-on-demand inkjet printer.

Thermal transfer printer: An output device which tranfers wax or resin ink from coated rolls or ribbons in contact with the substrate, one colour at a time. Provides intense colour, is a small size but has low resolution.

Thermo-autochrome printing: Paper with three layers of temperature sensitive colour (CMY) is activated by a thermal or ultra violet head in three passes. It is used in conjunction with a digital camera and limited to small sizes.

Thermography: A cheap commercial alternative to die stamping. A relief or lithographic image is dusted with powder which expands when heated. There is no indentation at the back of the sheet. Used mainly for invitations.

Thinners: Liquids or gels used to thin inks and clean brushes, rollers etc.

Thixotropic: Liquids, such as some inks, which become more fluid when worked and thicker when resting.

TIFF: Tagged image file format computer file used to store pixel-maps.

Tile: When a digital image is too large to be printed on a single sheet the image can be divided into rectangular sections or tiles and each one printed.

Tin (Sn): Offset lithography was introduced in the 1870s to print on tin for packaging. Tin sheet can also be used for etching; the mordant is nitric acid.

Tint tool: A steel tool used in wood engraving to cut fine, even width, parallel lines.

Tinted lithography: Early lithographs used two stones, one black and one neutral colour. The second, neutral stone was covered in ink and highlights were scraped or rubbed away. This gave an effect similar to chalk drawings on tinted paper with the highlights added in white chalk. The idea was extended to double tinting with the addition of a pale blue stone for the sky.

Tinting: *See* anti-tinting.

Tinting medium: *See* reducing medium.

Tints: Any pale colour or the imitation of tone by textures or mechanical tints. *See* Ben Day tints and tinted lithography.

Tip: A sheet of paper is attached or tipped to another page or backing sheet by a thin strip of acid-free glue; often used when book illustrations are separately printed from the text.

Tissue: Thin absorbent papers used for blotting ink and to build textures on collagraph plates. Acid-free tissue is used to interleave prints in storage.

Title page: The page at the beginning of a book or portfolio of prints which gives the title, artist and/or author, publisher and date.

Toluene ($C_6H_5CH_3$): A strong, inflammable, aromatic hydrocarbon solvent used for de-greasing. Not recommended as it is toxic.

Tone separation: When all intermediate tones are eliminated and the image is black and white only. *See also* lineblock.

Toner powder: The black thermoplastic powder left in a copying machine cartridge can be used as a drawing medium in a suitable vehicle such as distilled water or surgical spirit. Used for lithographic washes and washes on textured film for use as photo-positives. Gives good reticulation but it must be fixed using methylated spirit, white gas or lighter fuel. It can also be cured by heat over a hot plate or in an oven at 250F for 10 minutes. A mixture of ethanol and acrylic floor polish combines vehicle and fixitive. It is carcinogenic and care should be taken not to inhale the powder.

Toner transfer paper: A coated paper similar to lithographic transfer paper but specially formulated for taking laser copies for transfer to metal plates. Greater detail can be transferred than by using solvents and ordinary photocopies.

Toothbrush: Used in spatter technique and to brush debris from plates and blocks while working.

Torinoko: A Japanese paper made from *gampi*, popular with printmakers. A machine-made version is called *Shintorinoko*. *See also gampi*.

Tracing paper: Used to transfer an image to a new surface. Also used as a semi-transparent substrate called 'simulator' in the printing industry.

Tracking: When inking up lithographic plates or stones, consistent rolling up or tracking reduces lapping and other roller marks.

Tradigital: *See* hybrid print.

Trial proof: A working proof.

Transfer ink: A stiff ink formulated to hold transferred images in lithography.

Transfer lithograph: A print where the image is drawn on transfer paper.

Transfer paper: A gum arabic coated paper used in lithography which enables the artist to draw the image outside the print workshop. It is later transferred to stone or plate. Proprietary brands are available but it is also made in the workshop for special requirements.

Transferring process: Where an image is moved from one surface to another.

Transparent original: Photographic film which transmits light through its substrate.

Transparent prints: *See* protean print.

Transposition: Reversal black to white, positive to negative or moving an image to a new position.

Trapping: A colour printing term for the small overlapping of colours necessary to avoid white gaps when paper or film expands or contracts or there is a slight misregistration of colours during printing.

Trial proof: A proof to test registration, colour, paper and position.

Trichromatic: Three of the four standard process colours (CMY). Also printing of colour halftones using only the trichromatic inks. *See also* CMYK.

Trimming: The cutting down of the margin of a print, usually to fit a frame, is not considered good practice. The margin of paper round an image is carefully chosen by the artist and is part of the whole print.

Triple ink: A trade name for a lithographic plate base similar to asphaltum.

Trisodium phosphate (Na_3PO_4): The sludge formed by graining lithographic plates. It is kept on the steel graining balls to inhibit rust between graining sessions.

Tub sizing: A paper which has been surface sized after formation.

Turn-in: An extra width of cover paper added for turning over card or a book cover.

Turpentine: An oleo-resin secreted by several coniferous trees is then distilled and used as a grease solvent.

Turpentine substitute: White spirit (UK) or mineral spirits (US) is distilled from petroleum and used as a cheap grease solvent.

Tusche: An ink emulsion used to draw or brush on lithographic stone or plate. It is made in liquid, paste and stick form. Also used for tusche washes when dissolved in distilled water or a solvent.

Tympan: A sheet of brass or a high-density plastic such as polycarbonate on a direct lithographic press. It is lowered onto the stone/plate and paper sandwich and protects it from the friction of the scraper bar. On a relief platen press the tympan is a double metal frame covered with strong paper in between which the printing pad or packing is held to protect the printing paper and block from direct contact with the platen.

Type face: The design of a font of hot metal cast type used in letterpress or the design of a computer font.

Type high: The standard height of metal type is 23.3mm (0.918 in.). The measurement varies slightly in Europe. If blocks or halftones are to be printed in the same forme as type matter they must be type high.

Typogravure: Another name for relief halftone printing.

U

Ultra violet light (UV): Electromagnetic light which hardens most photographic printmaking emulsions and photopolymer compounds. Care must be taken when using it by shielding the eyes and skin. It is carcinogenic.

UMD: Ultra micro dot technology used in some inkjet printers.

Undercutting: If an image on a plate or block is undercut at the edges it may breakdown under pressure. Also when light creeps under a negative or positive because contact is bad, the film is too thick or the emulsion is up rather than down it results in a thinner image.

Undertone: The hue of ink, which may be thick or transparent, when white light is reflected off the paper substrate through the ink.

Unique impression: A single print which is not repeatable in that particular form; could also be a trial proof, an abandoned image or a monoprint.

Unlimited or unrestricted edition: An edition which is not signed and numbered and without a stated total print run.

Unpublished plate: A printing matrix so far not published, usually a work found after the artist's death which may be published posthumously.

Urazuri: A Japanese term for printing on the back of the paper giving a delicate impression.

USB: Universal serial bus which connects peripheral devices to a computer.

V

Vacuum bed: A screenprinting table with a vacuum base which holds the printing paper flat in spite of the suction exerted by the ink and squeegee. A vacuum bed is also used in exposure units.

Varnish: A clear, sticky substance used as a vehicle in inks and to adhere metallic foils and powders. Natural vanish is made from boiled linseed oil. Synthetic varnish such as alkyd varnish dries fast and is scratch-resistant and usually used to print on metal.

Varsol: Trade name for naptha used as a grease solvent. Called Stoddard solvent in the US.

Vaseline: Trade name for petroleum jelly. It is added to ink to soften it.

Vase-oleo: An early screenprinting technique.

Vatman: The handmade paper craftsman who lifts the pulp from the vat using a mould and after draining hands it to the coucher. *See also* coucher and layman.

VCA: Vegetable cleaning agents have been formulated as an alternative to irritant solvents for cleaning up oil-based inks.

Vector-based images: Computer term for geometric images built up from lines, curves, shapes and type which is not broken up into pixels and so not dependent on qualities of resolution. These images lend themselves to intaglio and relief printmaking.

Vector engraving: Digital information drives an engraver which cuts into metal, wood, lino, plastics etc. to a controlled depth or right through the material.

Vectorisation: Computer software conversion of a pixel-mapped image into a vector image.

Vegetable oil: Cheap culinary oil is used as an alternative solvent for oil-based inks. After softening and cleaning on rags or paper, a final clean is made with a paste of magnesium carbonate and water, or soap. *See also* VCA.

Veiner: A steel v-shaped tool used in woodcutting.

VEINER

Vehicle: The base liquid which carries pigment. It can be water as in watercolours, gouache, drawing ink or Asian printing colours or varnish, acrylics, alkyds, oils or cellulose paste for printing inks; small quantities of other substances will also be added to create a suitable viscosity and drying time for each medium.

Vélin: French for wove paper.

Vellum: The inner skin of a young kid or calf is not split but exposed to lime, scraped and rubbed with pumice and processed for use as a manuscript substrate. It is imitated by paper substitutes. Vellum can be printed by most methods. *See also* parchment.

Verdigris: A green patina which forms on copper in in a damp atmosphere - it is poisonous and plates should be protected in storage.

Vergé: French for laid paper.

Verso*:* The left hand page in a book.

Vertical etching tank: Used to hold etching plates vertically in ferric chloride or Edinburgh etch solutions, An aquarium aerator circulates the etchant and speeds up the etching.

Victory etch: A UK trade name for a popular lithographic etch containing gum arabic, asphaltum and nitric acid.

Vinegar solution: A mixture of vinegar and salt can be used as a de-greasing agent and for de-oxidising copper sheets. It is a mild etch.

Vinyl acetate: A synthetic resin used on lithographic plates as a printing base to give a tough film.

Vinyl inks: High gloss screen inks with a vinyl base for printing on paper or plastics; should be avoided for health reasons.

Vinyl resin: Used to make a coating for lithographic transfer paper.

Virgin wax: *See* beeswax.

Viscosity: The relative fluidity of printing ink.

Viscosity intaglio printing: A printing technique developed by S. W. Hayter in the 1930s based on the premise that inks of different viscosities will not mix. Colours of different viscosities can be layered on the printing plate for multi-coloured printing.

Vitreography: Intaglio from glass plates.

VOC: Volatile organic compounds.

Voltaic etching: An 19th century name for electrotyping.

VPL: Digital visual programming languages are being developed to enable artists to devise programmes using graphics on the screen rather than diagramatically.

VSD: Variable sized droplet technology used in advanced inkjet printers thereby improving resolution and colour,

W

Wallpaper paste ink: Cheap screenprinting ink made from cellulose paste and dye or pigment.

Washi: A collective name for all Japanese paper.

Wash out: A stage in the processing of a lithographic image when the drawing material or ink is removed using turpentine or another solvent.

Washing up: The cleaning of all matrices and tools after a printing session.

Waste sheets: Sheets of paper used during proofing and setting the registration and pressure on the press. Usually recycled several times in the workshop.

Water of Ayr stone: A fine abrasive stone used to polish lithographic stones.

Water burn: Streaks and blotches in the image area on lithographic stone or plate when too much water is allowed to sit on the asphaltum

between etches or at the start of a printing run; water lifts the asphaltum by oxidization.

Water rejection: Small bubbles in intaglio ink caused by unevenly dampened paper or excessive ink.

Watercolour: Finely ground pigments bound by glue and dissolved in water.

Waterleaf: Paper without any size or surface coating. It is very absorbent and weak when wet but suitable for relief, lithography and some screenprinting.

Waterless lithography: A form of lithography where the water-attracting non-image areas are replaced by an ink-rejecting surface, usually a coat of a silicone compound. Water is not used, presses can run faster and paper is not affected by damp.

Watermark: A design in a sheet of paper seen when it is held up to light. It is made of thinner paper fibres

where a wire design on the mould or cylinder allows fewer fibres to be deposited. It usually shows the mark of the manufacturer but for special editions paper is made incorporating an artist's signature and/or the publisher's mark.

Wax: It is used as an acid or alkali resist; it is also added to lithographic crayon or other drawing materials.

Wax engraving: *See* cerograph.

Wax paper: Water-resistant wax-coated paper used as a barrier to protect anything subject to damp.

Wax proof: A simple way of taking an intaglio proof without a press: put melted wax on a sheet of strong paper, rub black pigment into the intaglio lines and put wax-side paper on plate and rub.

Wax releasing agent: Used with a plaster mould when casting paper.

Wedge: A lithographic stone or woodblock which is not truly level.

Wet wash: A lithographic technique used when no gum coat is on the stone or used between etches, during printing or when excessive filling in has occurred.

White gas: Similar to petroleum and lighter fuel. *See also* toner powder.

White ground: A form of lift ground invented by Frank Cassara in the 1960s. It is made from soap powder, titanium white pigment, linseed oil and water. *See also* lift ground.

White line engraving: A characteristic of wood engraving where the design appears as white lines on a dark background.

White spirit: *See* turpentine substitute.

Whiting ($CaCO_3$) (Chalk, calcium carbonate): In powder or block form used with ammonia to de-grease metal plates. Also used in intaglio printing to dry excess ink from the hand during the final wiping of the plate.

Wire brush: Used in woodcutting to exaggerate the grain of the wood by brushing away the softer wood growth.

WHMS: Workplace hazardous materials information systems operate in Canada.

Woodblock print: The Western term for a traditional Chinese or Japanese woodcut.

Woodburytype: Invented by W. B. Woodbury (1831-1885). He produced a gelatine relief which was hardened and placed on a steel plate

with a soft lead sheet on top. This was put through an intaglio press leaving an indentation in the lead. The lead was used as a mould for gelatine tinted with pigment. The resulting gelatine picture was hardened in alum solution. As a reproduction of a photograph it took far less time than making an autotype. The lead could also be printed directly or first electrotyped for strength. *See also* autotype and carbon print.

Woodcut: A print taken from a relief block of wood cut lengthways with the grain.

Wood engraving: A print taken from a relief block of wood cut end or cross grain. Sometimes the term is used by historians for a woodcut where engraving tools (finer tools) have been used instead of woodcutting tools.

Wood free: Paper which does not use mechanical wood pulp (which is made by grinding wood and includes lignin which yellows paper). Chemical wood pulp is made by extracting the lignin leaving pure cellulose fibres which are used in high quality papers.

Wood pulp: It was first used to make paper by Mathias Koops in 1800. After 1880 wood pulp gradually replaced rags in paper manufacture, now two-thirds of all paper uses wood pulp.

Working proof: *See* trial proof.

Workshop: The printmaker's studio which is, ideally, well-lit and ventilated, with a sound floor to bear heavy printing presses and with adequate space for all the activities which take place.

Wove paper: A papermakers' mould using fine woven wire was introduced in 1757. It gave a much smoother surface without visible laid lines. *See also* laid paper.

X

Xerography: The trade name for a common form of electrostatic printing (office copiers) where the image is recorded in electrical charges which then attract toner particles and transfer them to paper. Available for monochrome and colour printing, occasionally used by

DICTIONARY OF PRINTMAKING TERMS

artists. *See also* laser printers.

X-height: A typographic measurement of the size of a lower case letter x, without ascenders and descenders.

Xuan **paper**: A very absorbent Chinese paper traditionally used for water-based woodblock printing. It is made from the bark of the tan tree (*winceltis* or *pteroceltis tartarinowii*). The three-ply and thick white unsized versions being most popular though the single-ply, thin paper is used for very fine work.

Xylene ((CH$_3$)$_2$C$_6$H$_4$) (Dimethylbenzene): An inflammable, aromatic hydrocarbon derived from petroleum. It is used as a grease solvent but it is toxic and should be avoided.

Xylography: Woodcutting or engraving.

Y

Yap edge: On a book cover a little extra is allowed to turn over to protect the fore edge.

Z

Zinc (Zn): A metal used in sheet form for etching and lithographic plates. Grained zinc plates were first used for lithography by Alois Senefelder in 1818.

Zinc nitrate: Added to some etches for zinc lithographic plates; it is thought to inhibit oxidisation.

Zinco: A process lineblock made from zinc or an alloy used in letterpress printing.

Zincography: An obsolete term for zinc plate lithography.

Zip: A zip drive for a computer copies work from the hard disk and stores it on a zip cartridge. They are available in two sizes 100MB and 250MB.